The Birth of Modern Painting

The Birth of Modern Painting

TEXT BY GAËTAN PICON

SKIRA
RIZZOLI
NEW YORK

Published in the United States of America in 1978 by

Rizzoli INTERNATIONAL PUBLICATIONS, INC.
712 Fifth Avenue/New York 10019

Library of Congress Catalog Card Number: 78-59339
ISBN: 0-8478-0189-6

PRINTED AND BOUND IN SWITZERLAND

CONTENTS

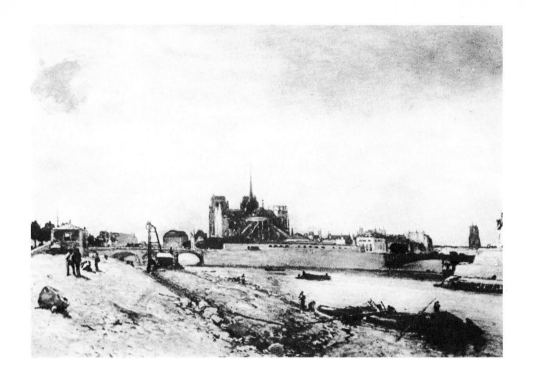

The Salon of the Rejected

Memory, let me but muse again, he used to put it, then, so well: "The eye, a hand..."

Mallarmé
(Medallions and Portraits: Edouard Manet)

When the Salon des Refusés—the Salon of the Rejected—opened in Paris on May 15, 1863, it was as if History were staging an event which, in the order of painting, would show all the signs of a break with the past and a new beginning. The great actors of the preceding play had disappeared or spoken their lines for the last time. Delacroix died on August 13, 1863, and the funeral announcements bearing his title, "Member of the Institute," subjoined the most distinguished epithet the profession could bestow: "History Painter." Ingres in that year was eighty-three and had just finished his last composition, which had dragged through so many years: *The Turkish Bath*. The scandal of the Salon des Refusés testified that the curtain was already going up on a new play whose

forces, to be sure, had been assembled in the wings for some time, but had been unperceived by the public. It was a drama with several leading characters but with one outstanding hero: Manet; and for which *Le Déjeuner sur l'Herbe*—whether applauded or booed—might have supplied a title.

And yet, if it is true that the theatrical event, above and beyond its anecdotal aspect, signalled a genuine starting point—that of a painting in which we still recognize the source of our own painting today—it has to be seen in the light of a historical development still in embryo, to which it gave birth unconsciously: something which was not yet but was to be. But in considering it we should also (a difficult mental gymnastic!) turn our backs on this perspective of the future and relive the shock

Johan Barthold Jongkind (1819-1891). View of Notre-Dame from the Seine Banks, 1863. (17 × 22¼") Private Collection.

7

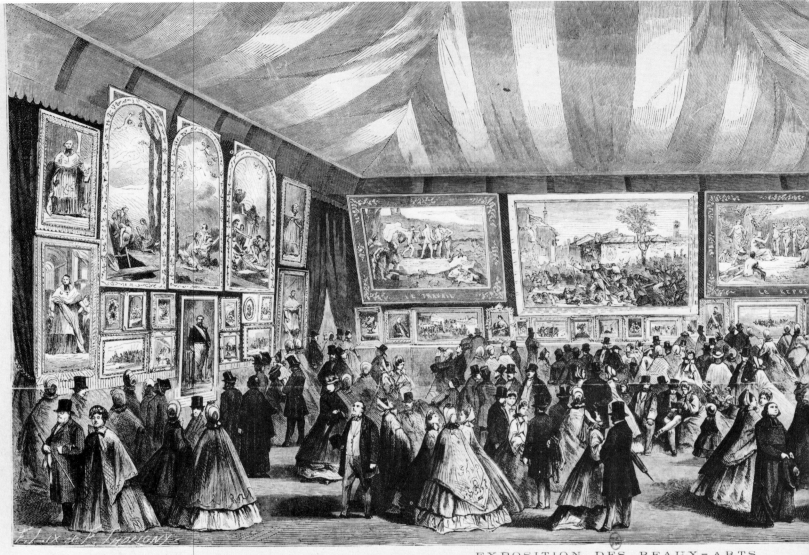

Exposition des Beaux-Arts

LE GRAND SALON CARRÉ (PALAIS DE L'INDUSTRIE).

Tout Parisien un peu fervent arrive facilement à se persuader que tout ce qui n'habite pas les bords de la Seine languit et conserve au cœur une éternelle tristesse. Nous croyons bien vite à la nostalgie du boulevard des Italiens, et nous déplorons avec une parfaite sincérité le malheur des gens qui vivent au bord du lac de Côme à Belgirate, ou au lac Majeur à Arona; nous nous appitoyons en pensant que la perspective Newski est sillonnée d'élégants drowski, et que ces infortunés boyards qui s'y promènent ne jouissent pas de l'ineffable bonheur d'applaudir l'Arnal du jour ou la Brohan de la veille, d'admirer le *Fromentin* ou le *Cabanel* nouvellement éclos.

Nous allons plus loin : Parisiens que nous sommes, nous circonscrivons la vie entre la Madeleine et le boulevard Poissonnière. Nous croyons qu'une brochure fraîchement éclose, partie de chez le *Barbin* du jour, va remuer le monde, et que les débuts d'une Dorine échappée de la Tour d'Auvergne doit passionner les Hellènes. Nous parlons d'*Athalie Manvoy* et des *Troyens* aux hidalgos et aux Moldaves comme si le *Figaro* était le *Moniteur universel*, et cela porte atteinte à notre amour-propre que les étrangers ne se tiennent pas au courant de nos chroniques et de nos coulisses. Nous citons le dernier mot d'*Augustine*, et nous étonnons qu'on ne nous donne pas la réplique quand nous fredonnons le dernier refrain que soupire Montaubry.

Alors, comme au fond l'homme est plus conséquent qu'il n'en a l'air, et que pour être journaliste on n'en est pas moins homme, on arrive, après tant de commisération, à vouloir apporter un soulagement à tous ces maux, et donner au moins à ce pauvre étranger, à ce triste exilé, une faible idée de toutes ces splendeurs.

Notre exposition des beaux-arts, avec laquelle (je l'espère pour eux du moins) tous les Parisiens sont aujourd'hui familiers, a été depuis deux mois l'événement sérieux; on s'est passionné pour telle ou telle toile; il y a eu les *cabanelistes* et les *baudrystes*, et c'est un grand honneur qu'on a fait à ces deux artistes que de se diviser en partis en leur honneur. Nous essayons, chaque semaine, de donner aux absents une idée de l'ensemble de cette exposition, soit avec les comptes-rendus, soit à l'aide des gravures que nous publions. Aujourd'hui, nous avons fait dessiner le grand Salon carré, et on jugera des dispositions prises par l'administration pour satisfaire tout le monde.

La lumière est aussi bien répartie que possible; on n'a pas éteint un tableau discret par l'éclat trop vo d'un sujet pétulant, ou, si cela se produit, c'est a dentel, et malgré les trois mille récriminations nous avons entendues, nous persistons à croire qu a de la part de la direction des musées un parti de bienveillance et d'intérêt général.

Ce Salon carré, qui existe de fondation, avait au fois une signification qu'il a perdue depuis. Le j ou plutôt l'administration s'érigeant en jury, mais pas en jury sans appel, faisait un choix des toiles lui paraissaient devoir mériter les suffrages, et, le posant dans ce salon d'honneur, en faisait pour a dire une *tribune*, où elle rassemblait les meilleu choses de l'exposition.

Il arrivait bien que le public ou les artistes alla chercher au fond d'une salle quelconque une œu ignorée et la plaçaient par leur suffrage parmi les m

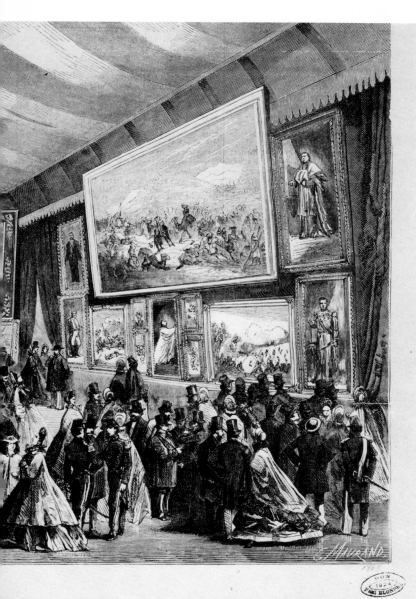

which has since worn off; see it, that is, as something then really taking place for the first time, although today everything induces us to put back or bring forward in time the liberating rupture, the event which rang up the curtain.

Let us recall the circumstances. In nineteenth-century Paris, where private galleries were few and exhibitions rare, the official Salon—as this periodic exhibition of painting and sculpture was called—was the artist's golden opportunity to show his work. Now the jury that chose the pictures was composed almost entirely of academicians, members of the Institute (the Institut de France, the highest institution of learning in the country, which included the Academy of Fine Arts). The revolution of 1848 had imposed a jury of independent artists and decreed an annual

The Official Salon of 1863: View of the Main Gallery. Print by Frédéric Lix and Thorigny published in "Le Monde Illustré", Paris.

Honoré Daumier (1808-1879). The Influential Critic Walks Through. Caricature published in "Le Charivari", Paris, June 24, 1865.

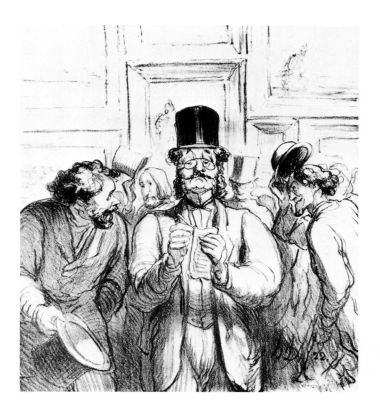

Salon at which all works submitted would be shown. But the Institute rapidly regained its stranglehold, and in 1857 the annual Salon was abolished. From then on protests continued to grow against a biennial Salon, against the composition of the jury, and against the criteria of selection and the excessive number of rejected works.

In 1863 3,000 artists submitted 5,000 paintings and sculptures; only 2,000 were accepted. Among the rejected canvases were some signed by well-known painters, such as Chintreuil, Harpignies and Jongkind. The Emperor, becoming uneasy, spoke about the matter to Count Walewski, the Minister of Fine Arts, and to the Count of Nieuwerkerke, director general of the French national museums. A deputation headed by Edouard Manet and Gustave Doré, the illustrator, waited on Count Walewski: he received them with due courtesy, but dismissed their appeal. In vain the excluded artists applied to Louis Martinet, director of a large picture gallery on the Boulevard des Italiens. Their cause seemed lost. Then, an unexpected announcement appeared in the official government paper, *Le Moniteur*, on April 24, 1863:

"Numerous complaints have reached the Emperor about the works of art rejected by the jury of the Exhibition. His Majesty, wishing to let the public judge for themselves whether or not these complaints are well-founded, has decided that the rejected works will be shown in a section of the Palais de l'Industrie. This exhibition is voluntary, and those artists who do not wish to participate have only to notify

Edouard Manet (1832-1883). Sketch for "Le Déjeuner sur l'Herbe," 1862-1863. (35¼ × 45¾") Courtauld Institute Galleries, London.

10

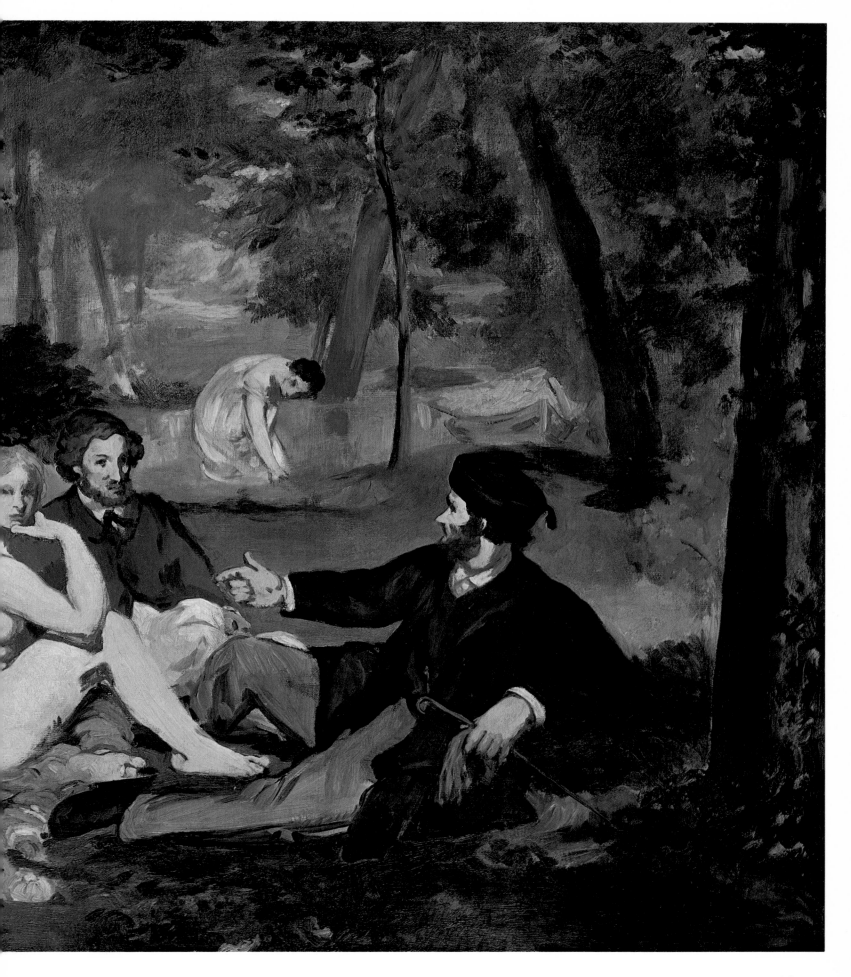

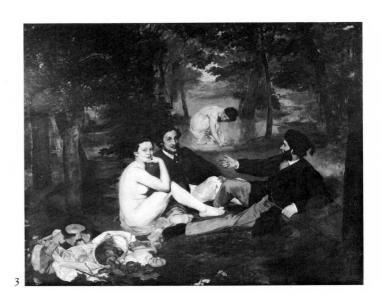

1

3

Is this drawing? Is this painting? Manet thinks he is being firm and strong. He is only being harsh; and oddly enough, he is as limp as he is harsh... I see clothes without feeling the body underneath that supports them and justifies their movements.

Castagnary

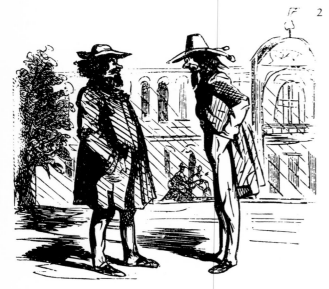

— Mon tableau a été reçu à l'exposition! Personne ne le regarde.

— Le mien est dans les refusés. On s'écrase pour le contempler.

People started laughing from the doorway.

Charles Brun

When your friends are ill, you don't laugh at them, you see that they are looked after.

Ernest Chesneau

the Rejected

Manet, with his instinctive boldness, has entered the realm of the impossible. We flatly refuse to follow him.

Paul Mantz

The exhibition of the Rejected might just as well be called the exhibition of the Comedians. What pictures! Never was such a triumph of laughter better deserved.

Charles Brun

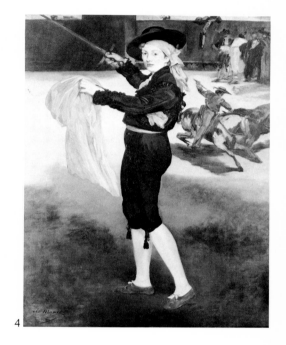

The three pictures by Manet look like a challenge to the public, which is provoked by the over-bright colours.

Thoré-Bürger 4

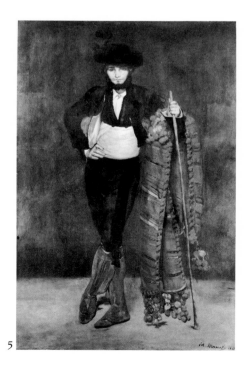

5

1. Catalogue of the Salon des Refusés, 1863: Title Page.
2. Caricature by Cham published in "Cham au Salon de 1863. Deuxième Promenade": "My picture was accepted at the exhibition and nobody's looking at it.—Mine's with the Rejected and people are flocking to see it."
 Edouard Manet (1832-1883):
3. Le Déjeuner sur l'Herbe (The Luncheon on the Grass, exhibited at the Salon des Refusés under the title "The Bath"), 1863. (82 × 104″) Galerie du Jeu de Paume, Louvre, Paris.
4. Victorine Meurent in the Costume of an Espada, 1862. (65⅜ × 50¾″) The Metropolitan Museum of Art, New York. Bequest of Mrs H. O. Havemeyer, 1929. The H. O. Havemeyer Collection.
5. Young Man Dressed as a Majo, 1863. (74 × 49¼″) The Metropolitan Museum of Art, New York. Bequest of Mrs H. O. Havemeyer, 1929. The H. O. Havemeyer Collection.

the Administration, which will return their works to them without delay."

A few days before the opening of the official Salon the Emperor had paid a surprise visit to the Palace of Industry, turned over some of the rejected canvases with his gloved hand, and concluded that they were no worse than the rest. And he had brushed aside protests by the Administration calling his attention respectfully to the fact that a barrier was essential, that the déclassé artists were a danger to society. Thus opened, on May 1, 1863, the official Salon, over which throned Flandrin's *Napoleon III* and the portrait of the Empress by Winterhalter, and where all the mediocre canvases could be viewed, notably the two battle scenes by A. P. Protais, for which Louis Napoleon would pay 20,000 francs, Cabanel's *Birth of Venus*, J. P. Laurens's *Death of Cato of Utica* and Alfred Stevens's *Set To Go Out*. But there were also paintings by Corot (*Study at Ville-d'Avray* and *Rising Sun*), Courbet (*Fox Hunt* and *Portrait of Laure Borreau*), Millet (*A Shepherd Bringing in His Flock, Woman Carding Wool, Peasant Resting on His Hoe*), Rousseau (*Clearing at Fontainebleau* and *Pool Beneath the Oaks*), Puvis de Chavannes (*Work* and *Rest*), Daubigny and Guigou, as well as Fromentin's *Hawking in Algeria* and an *Episode of the Flood* by Gustave Doré.

Fifteen days later opened the Salon des Refusés: the Salon of the Rejected, "Exhibition of Works not Accepted," also called the Salon of the Defeated and even, in a lower voice, the Emperor's Salon. Some of the rejected artists did not dare to exhibit; only 1,200 out of 2,800 left their works, and the catalogue, owing to administrative sabotage, listed only 683 titles.

As for Courbet, his was a special case. He was represented in the official Salon because,

having previously been awarded a medal, he was accepted without examination; but one canvas, *Return From the Conference*, which showed inebriated priests straggling along a road and was rejected for indecency, could not be hung anywhere, and Courbet finally had to exhibit it in his own home. But grouped around Manet were Whistler (*The White Girl*), Jongkind (*Winter Effect, Canal in Holland, Ruins in the Nivernais*), Fantin-Latour (a portrait and *Enchantment*), Chintreuil, Harpignies and Pissarro. Backed by the Emperor, the artists won the institutional campaign: the annual Salon was re-established, a retired general named Vaillant replacing Count Walewski as Minister of Fine Arts; the Institute was supplanted; henceforth three-quarters of the jury would consist of artists participating in the exhibition who had already won medals, the remaining one-fourth being administrators.

Today, when we return to *The Bath* (the original title of Manet's *Déjeuner sur l'Herbe*) we see it to be closely bound by the tradition of the museum. It takes its inspiration from Giorgione's *Concert Champêtre* in the Louvre and Raphael's *Judgment of Paris*, which Manet knew from the engraving by Marcantonio Raimondi. The composition remains decorative; we imagine the canvas as being set into a wall, part of the architecture, in the Italian tradition; the suggestion of perspective is still noticeable. As for the peculiarities of the technique, what can we find there that isn't to be found already in the Dutch masters, especially in Frans Hals, or in the Spanish masters whose influence is freely confessed in other exhibited works by Manet (two canvases: *Young Man Dressed as a Majo* and *Mademoiselle Victorine in the Costume of an Espada*; and two engravings: *Little Cavaliers* and

14

Philip IV after Velázquez)? How can the rupture with tradition be located here? For indeed it may be debatable whether a museum of Modern Art should begin with the earliest Cézannes, Picasso's *Demoiselles d'Avignon*, or with the first abstract watercolour by Kandinsky; but who dreams of having it start with the *Déjeuner sur l'Herbe*? The Jeu de Paume, where it now hangs, is part of the Louvre Museum. And if we hesitate to find a parting of the ways in Manet's work we shall find it still less in the painters who shared with him the hospitality and the honour of the Salon des Refusés and who, besides, scarcely differed from some great artists accepted by the official Salon. If there is a chasm, then, can we still perceive it? Has it not long since been "reclaimed," made hard to distinguish, obliterated by a tradition from which it escaped only superficially, in the shape of an anecdote?

But it may well be asked whether the rupture, at the moment it occurred, was truly felt. Hadn't the accidents of the little affair—its dramatic possibilities—given the event an appearance out of all proportion to its immediate and specific reality? To be sure, a group of painters rejected by an official selection committee had decided, for the first time, to show their works independently. But they had followed the suggestion of the Emperor who, preferring Protais and Baudry to Manet, resembled anything but a far-seeing connoisseur, and had acted in keeping with a pose of liberalism in order to spike the guns of the Institute, which was a centre of opposition. Sympathies, "morality," politics had stepped in to help shape the event. Certainly from an administrative point of view the Rejected had won a lasting victory. But the relations of art with official bodies and with the State do not constitute decisive chapters in its history.

Manet's canvases, of course, caused a scandal. But the general reprobation which led Castagnary to write in *L'Artiste*: "We know now what a bad picture is," and which brought the words "melancholy and grotesque exhibition" from the pen of Maxime du Camp in the *Revue des Deux Mondes*, fell equally on Courbet and Millet, "official" painters whose talent no one placed in doubt: a proof that the painter's subject, which for us today has dwindled to such minor importance that we risk overlooking it, was in this case the chief consideration. Paul de Saint-Victor wrote: "Monsieur Millet advances further and further along the path on which Monsieur Courbet went astray. Art for him is confined to the servile copying of unworthy models. Millet lights his lantern and goes looking for a cretin. He had to look for a long while before finding his peasant leaning on his hoe. Such types are not common, even in the Bicêtre lunatic asylum." Manet, as Zola said, had introduced "a new way of painting," and it would not go unnoticed! But if none of his admirers—not even Zola—saw the profound and active originality of this painting, no detractor would ascribe Manet's failings to irremediable incapacity, as Cézanne's detractors did later in his case: Manet was simply advised to paint other subjects and to pursue further studies. Ernest Chesneau, for example, wrote: "Manet will have ability when he has learned drawing and perspective; he will have taste when he has given up choosing his subjects in order to create a scandal."

We find these qualifications, employed by almost all his opponents, on the lips of his supporters as well. Zacharie Astruc was the one

who showed the most lucid enthusiasm: "He is the brilliance, the inspiration, the tang of this Salon. Manet's talent has a decisive side to it, something trenchant, sober and energetic, which explains his nature at once reserved and exalted; above all receptive to intense impressions." Fine words, no doubt, but they carry no assurance that their author really knew he was in the presence of a history-making event. As for the famous article written by Zola in 1867 and aptly entitled "A New Way of Painting," the text climbs down a bit from its title: "This reckless man whom we have mocked is in fact quite prudent in the methods he uses...In a word, if I were asked what new tongue Edouard Manet speaks I should reply: he speaks the language of simplicity and accuracy."

Did Zola use these words in order to reassure the public? I don't think so. Simplicity, accuracy—those are the values he prizes and which he finds expressed here: later he was to blame Manet and his disciples for abandoning them. Moreover, if Zola believed, or forced himself to believe, in the latent genius of the age, he did not consider, and never would consider, that the painter who would incarnate that genius had appeared on the scene. Zola never ceased to designate as precursors and pioneers those who would turn out to have been genuine creators ; he never stopped waiting for what had already arrived.

This attitude was that of Baudelaire as well, except that his assessment of Manet—despite the charm he discovered in "the pink and black jewel" (*Lola de Valence*)—falls short even of Zola's. Baudelaire never spoke of Manet as he did of Delacroix, nor even of Constantin Guys; he never saw in Manet the artist appointed by destiny to express the "heroism of modern life." If, in 1862, he sang Manet's praises, he sang them along with those of a second-rate artist like Alphonse Legros: "Messrs Manet and Legros combine a decided taste for reality—already a favourable symptom—with that vivid and far-reaching imagination, bold and sensitive, without which it must indeed be confessed that all the highest faculties are but servants without a master, officials without a government." Baudelaire lived in a state of expectancy: "It is true," he wrote in his review of the 1846 Salon, "that the great tradition has been lost and the new one has not been established." But he did not see in Manet the man who would put an end to his waiting. And if, in the end, he seems to have divined Manet's importance, he mingled his recognition with a rejection of the art which Manet foreshadowed. His letter of 1865 is well known: "You are merely foremost in the decay of your art."

As for the Goncourt brothers, who in these critical years from 1862 to 1865, except in their excessive esteem for Decamps, were scarcely to be taken in by mediocrity ("Solid esteem is reserved for those who were not born to be painters; Flandrin is an example") nor slow to recognize talent or genius, speaking appropriately of Millet and especially Daumier, when it came to Manet they found nothing to say.

And yet, what might be mistaken for the chance arrangement of a page of history represents a truth not seen at once and which now risks being seen no longer. Yes, in Paris, in 1863, something really began to happen on the stage of painting, and what we find in it of tradition takes on a completely different meaning. A new era opens, an era whose ultimate avatars we are living through today. "Painting", said Gauguin, "begins with Manet".

The End
of the
Imaginary

The figures of man's traditional imaginings still dominated French painting during the first half of the nineteenth century. David did not replace mythology by history so much as he gave to history the dimensions of mythology; Gros did likewise, although he was criticized for painting mere soldiers rather than heroes. The figures in Géricault's *Raft of the Medusa* are based on the accounts of this famous shipwreck which he read in the newspapers, but they have been blown up to heroic proportions; the same is true of the figures in *The Fualdès Story*, a sensational murder case that filled the columns of the daily press in 1817.

History was worthy of classical antiquity, from among whose marble columns issue such paintings as Gros's *Bonaparte Visiting the Plague-House of Jaffa* and David's *Death of Marat* and *Death of Bara*. The portrait which Prud'hon left of the Empress Josephine—and of his own reverie—does not define him so well as do his Hellenistic dreams, his pictures of Psyche and Venus or his famous allegory of *Justice and Vengeance Pursuing Crime*. The perfect likeness

Pierre Puvis de Chavannes (1824-1898). Sketch of Salome (detail). Cabinet des Dessins, Louvre, Paris.

of the *Two Sisters* tells us less about Chassériau than we learn from the nudity of his imaginary Esther or the allegorical murals he painted for the Cour des Comptes (Audit Office) on such themes as Peace, Silence and Meditation. The vast compositions which may be seen today in the Grande Galerie of the Louvre appear in their emotive gesticulations as so many farewells to a grandeur slowly being submerged.

And in the last works by Ingres and Delacroix, contemporary with the first works of Manet, how they gleam, those figures of the Imaginary, before going out in the blaze of a setting sun!

And in Manet's first canvases something, to which we shall attempt to give a name, comes towards us for the first time. But it comes in place of something else, which has just disappeared; and that absence haunts the dazzling new radiance.

Let us compare Delacroix's frescos in the church of Saint-Sulpice (*Jacob Wrestling With the Angel, Heliodorus Driven From the Temple*) as well as Ingres's *The Golden Age, Jesus Among the Doctors* and *The Turkish Bath* with—I won't say *Olympia* or *The Fifer*—but even the most traditional of Manet's works: the *Déjeuner sur l'Herbe*. What a gulf divides them! With Delacroix, as with Ingres, an image formed slowly in the mind, growing out of a reading of the Bible or that letter of Lady Mary Wortley Montagu's on the warm baths of Adrianople which Ingres came across in 1819. Given into the keeping of the dream, entrusted to the toil of the drawing, of the sketch, the image was patiently towed before being deposited at last on the shore of the painting. We feel inclined to say of each figure represented that *it has arrived at that point*. The attitudes of the figures seem the outcome of

Eugène Delacroix (1798-1863). Heliodorus Driven from the Temple (detail), 1861. Wall painting, chapel of the Saints-Anges, church of Saint-Sulpice, Paris.

previous actions and ordeals: the static quality of Ingres prolongs and preserves the equilibrium of a position selected with a knowledge of all the circumstances; with Delacroix the violence of the movements reveals that the drama has reached its climax.

And just as each figure emerges from a past which gives it all its significance, so it also belongs to a space from which it has been removed and with which the picture communicates. Each sign is the *now* of some once-upon-a-time; each, likewise, is the foremost point of a remote distance. In *The Turkish Bath* the arrangement of light and shadows brings into fore-

ground prominence the back and turban of the woman playing the viol. Leaving her, our eye plunges into the depths of the canvas, where there seem to be knotted more sombre groups the size of figurines, to travel at last towards the door which, although perhaps walled up, leads somewhere else. And it is from somewhere else too that the light comes which, in the church of Saint-Sulpice, falls on Heliodorus thrown to the ground by the horseman and scourged by the angels; it comes from a space we cannot see, since our visual field is restricted to that of the picture, but with which the picture is in touch. The image is strictly centred, closed within itself, but the very sharpness of its frame-line attests that it had to be clipped out, as it were, extracted from the continuum in which it properly belongs. Each image gives the sign of another, an otherwhere; each is borrowed from the store of a world, an imaginary, and a knowledge containing everything that is worth representing—the artist choosing from that store the worthiest object, the finest moment, the optimum conditions.

What strikes us in Manet, on the contrary, is a kind of total presence of the image. To be sure, the image is less strictly centred, more open; and yet it possesses a kind of independence, as if, advancing towards us, it had severed its ties with the spatio-temporal otherwhere. The scene is played here and now, before us; the attitude of the figures is no longer the result of a previous action; it is the fact of the moment, not a history but a presence; and whereas the figures of Ingres or Delacroix look at each other or gaze far off at what is not shown but nonetheless exists, the woman in the *Déjeuner sur l'Herbe* does not look at her companions but at the "flash" which takes her

likeness; the portrayal has less relevance to what is portrayed (either the whole or any of its parts) than to the act of representation—as does, before this of course, the intent gaze of Velázquez which appears in his own picture: *The Maids of Honour (Las Meninas)*. And the space that remains suggested is not so much a distance into which we plunge as a "void" which delegates to us whatever appears in the foreground—the only plane that matters. The scene has not been imagined but seen; it is not a selection of images from the imaginary but an actual encounter. According to Antonin Proust, Manet had the idea of painting a nude in the transparency of the atmosphere one Sunday at Auteuil while observing the skin of the women bathing and the white skiffs as they furrowed the river, their clear note rising above the deep blue of the water.

It was the end of the imaginary, of everything belonging to collective memory and reverie; the end of models which the individual does not meet in real life but which he can reconstruct, bring to life: legends and myths, great actions and historical figures, ideal representations of beauty, ideal objects of desire. It was the end of the world as an entity, a unified whole in space and time existing behind every image presented; the end of the world as a hierarchy in reference to which each image selected had its place and justification.

More precisely, what comes to an end here is the possibility of giving back to that imaginary universe a universal authority, of making it live for everyone—or at least for most people. For we do indeed meet its figures again, but either they have become cadaverous bodies or garments no longer covering any bodies at all, or else they are dreams, fascinating at times, but

dreamed in solitude and not easy to communicate. From this year 1863 onwards the history of painting was to be essentially the history of a mode of perception and not of an imagined world: Cubism, abstraction, action painting are the consequences of a painting of the perceived, even if they deviate from it by combination or invention; and symbolist or surrealist painting appears as a marginal force, a force of opposition.

Degas, a classicist by temperament, began with large-scale historical compositions: *Spartan Girls Challenging the Boys, Alexander and Bucephalus, Semiramis Building a City, Jephtha's Daughter, The Misfortunes of the City of Orleans.* But for him museum painting already counted for no more than one half of his experience, one term of the antinomy ("Ah! Giotto," he wrote in a notebook kept in youth, "let me see Paris! Paris, let me see Giotto!") He was to see Paris better and better, in the footsteps of Manet: *The Bellelli Family* (c. 1860) is still an admirable classical group, but right on its heels come the jockeys captured at the instant preceding the start of the race, and here is Manet himself, drawn sitting on a chair, his hat on his knees and the skirts of his frock-coat hanging down to the ground.

To be sure, painters like Puvis de Chavannes, Gustave Moreau and later Odilon Redon, as well as engravers like Meryon, cannot be passed over in silence! But in spite of their talent, even their genius, they remain on the periphery; they do not, like Manet or Degas, Jongkind or Renoir, Pissarro or Monet, form part of the work force of the new painting. Their isolation,

Edouard Manet (1832-1883). Le Déjeuner sur l'Herbe (detail), 1863. Galerie du Jeu de Paume, Louvre, Paris.

their "alienation" produced its fatal consequences: the traditional imaginary world which is to be found in the spirit and the very techniques of their art appears either as somewhat weakened, its temperature lowered, as in Puvis de Chavannes, or on the contrary it is characterized by something feverish, by a dream atmosphere, paramnesiac or frankly delirious, as in Meryon. Since the imaginary is no longer life it can only be their dream, their madness—or their idea: a concept, which risks being empty and becomes thoroughly so when we pass from Puvis de Chavannes to academic painters like Cabanel or Baudry.

That painters so obviously mediocre as Cabanel or Baudry, who exhibited at the official Salon, should have been the heroes of a critical reception which made Manet its scapegoat (even though the critics in question lacked neither intelligence nor a discerning eye: it was Théophile Gautier who defined Baudry's *The Pearl and the Wave* as "the strange in the exquisite, the rare in the beautiful," and it was Paul de Saint-Victor who awarded the palm to Cabanel's *Venus*) testifies to the very depth of the abyss which had opened. Except for a few, no one knew that the traditional imaginary realm had become an impossibility; life went on according to habit, each retina recorded its consecutive images; few indeed perceived that the art which took up once again the themes and compositional designs to which Ingres and Delacroix had given a last solar radiance was now emptied of its lifeblood. What was disappearing held by so many roots that it could not die instantly, and what was being born could not be accepted all at once.

The issue was not the refutation of a doctrine, the supplanting of one truth by another, but a relocation of life. What had been fecund was simply fecund no longer, that was all; the sterility of the present only emphasized the fertility of the past. Baudry, Cabanel and Gérome vainly repeated the teaching of Ingres: primacy of drawing, repudiation of free brushwork, the conviction that the model is nature corrected by classical drawing, that the picture must be thought out before its execution, etc. All that was of a piece with the subjects they handled, but those subjects now spread death around them, whereas for Ingres they had lived, they were still alive.

But the young painters who rejected these subjects like so many corpses and who denounced the nullity of official art, perceived far better than the officials the genius of the masters to whom they were bidding farewell. They could see what had been alive as living, and they discerned, along with the sources of inspiration henceforth sealed up, those aspects they could use to advantage. Degas, for example, started out by copying the drawings of Ingres, and it must not be forgotten that Ingres's painting, heralding a modernity which, to be sure, would be revealed only later, appeared to more than one critic of the day as *flat, Chinese* and *primitive*. But the lesson of Ingres, on the whole, ran counter to the quest of the younger painters, whereas they admired and retained the art of Delacroix, even if they could no longer share his spirit.

In 1864 Fantin-Latour, who a few years later was to paint a homage to Manet (*The Studio in the Batignolles Quarter*), painted a *Homage to Delacroix*, who had died the year before. Bazille and Monet, as art students, had often watched Delacroix at work from the pavement outside the windows of his studio at

No. 6, Place Furstenberg. Odilon Redon had seen him at a ball and did not have the courage to speak to him; then followed him home through the streets that night without venturing to strike up a conversation. It was their common admiration for Delacroix which brought together Cézanne and Victor Chocquet, a customs official and art collector.

And the younger artists' admiration was not, after the manner of nostalgia, reserved for the irretrievable—for what, as Baudelaire said,

would *never-never* be found again. For they succeeded in finding in Delacroix the two elements whose dialectic would govern their art: on one hand a more precise analysis of the sensation of colour, the accommodation to a closer reality; on the other, not only the freedom of execution but the hint for that

Edouard Manet (1832-1883). Copy of Delacroix's "Barque of Dante," 1854 (?). (13 × 16⅛″) The Metropolitan Museum of Art, New York. Bequest of Mrs H.O. Havemeyer, 1929. The H.O. Havemeyer Collection.

execution to show itself, the canvas henceforth evincing the trace of gestures which, although directed at the object, acquire equal importance with it. It is Delacroix who speaks in his *Journal* of "that air, those reflections, which form a whole from objects of the most disparate colours." It is he who eulogizes the rough drawing, the sketch which gives "a wider scope to the imagination." It is he who, extolling brushwork ("With Titian begins that freedom of handling which breaks with the stiff aridity of his predecessors and is the perfection of painting"), sees in it a form of language that need no more concern itself with being present in nature than the hatching of an engraving or the contour line of a drawing.

However, Delacroix recognized his heirs neither in the academic painters who preserved appearances without sustaining life, nor in the painters of the Salon des Refusés who preserved life while casting off appearances. After eulogizing that brushstroke of Titian's he adds that it has "nothing to do with the monstrous abuse of brushwork and the slack manner of the painters of artistic decadence." And Delacroix is thought to have inspired the following lines by Gustave Janicot in the *Gazette de France*: "Monsieur Manet has all the requisite qualities to be rejected unanimously by all the juries of the world. His keen sense of colouring stabs the eyes like a steel saw; his figures are cut out as if by a die, with a crudeness unsoftened by compromise. He has all the bitter savour of those green fruits destined never to ripen." As for Ingres (who, however, is said to have appreciated Manet's first portraits), he never ceased to complain of a Paris "delivered up to the most violent artistic anarchy." The mediocrity of some did not escape them, but the

genius, or rather the artistic purpose of others, did.

The new tradition was being forged, but they did not see it. The stage, to them, seemed empty. And so, in fact, it was—of the art they had served! Why did it become empty just at that moment? Why did the imaginary, which had lived for them, disappear just then? Delacroix, in an entry in his *Journal* dating from 1857, gives the various and convergent reasons: "The absence of general taste, the gradual increase in the wealth of the middle classes, the increasingly imperious authority of a sterile criticism whose essential nature is to encourage mediocrity and discourage great talents, the inclination of minds towards useful sciences, the ever-brightening lights that frighten away the creatures of imagination..."

The traditional imaginary disappeared from painting because it disappeared from the mind, from society (where it survived only in an artificial, hypocritical, denatured form). Its blueprint for art had to make way for another. And it is through not having understood the significance of this new blueprint—and through having remained behind following the old one—that talent which took the wrong direction miscarried while other talent, perhaps not superior, gained from the right direction an added force. Gérome painted his dubious *Cockfight* and left some beautiful sketches; a bouquet of chrysanthemums in that lugubrious *All Saints' Day* by Friant aroused the jealousy of Vuillard.

The world in which classical painting had its being was haunted by invisible presences which did not always belong to a historical past, but which all derived from a spiritual past—in the sense that, for a long time, ever

since the origins of Western culture, they formed the knowledge or intuition of the spirit. The spirit thought; art created while turning its head to look back...Towards the middle of the nineteenth century the new Orpheus was forbidden to look back; man no longer lived looking over his shoulder, for he was forging himself a new history: that of the domination of the world, and its significations had not yet come to light. But this in no sense meant passing from a world of nostalgia to a world of the present. The cult of the past tells us less about the past than about the situation of being unable either to bring a doomed past back to life or to embrace new values. This was the situation of Ingres and Delacroix; it was by no means that of Poussin or Racine, still less of Raphael! Ingres and Delacroix still held by a last thread to the imaginary; and that is why their connection, at once enfeebled and exasperated, takes on that dazzling blaze, or that fever, of the setting sun. The romantic imaginary *is* a past, but the classical imaginary *was* a present.

It was a present—although the mind kept turning to look back—in the sense that its relation to the past had been lived as proximity, as embroilment; not conceptualized as a breach, as distance. Orpheus and Eurydice are not alien to the trees of Poussin as are the nymphs of Corot to his landscapes. And between the mythological and historical scenes of the seventeenth century, between Poussin's *Shepherds of Arcadia* and the battles of Louis XIV, there is not that gulf which divides the visions of Gustave Moreau from the things actually seen by Manet, or a nightmare by Fuseli from the *Marat* by David. And if classicism relived the past in the present, it was because the past, for it, had been not so much the temporal past, the anterior event, as the model, the reference supplied by a myth, a myth primitively revealed or dimly divined, of which each thing in classical art gave a sign: in classical art, as in the life of the world that corresponded to it, each form functioned as a symbol; and whatever is symbolized is not invented—or discovered—but remembered. What is signified is not necessarily the past in the historical sense, but *what is already there.* The progression, therefore, is not from an art of the past to an art of the present but (except for the romantic parenthesis prolonged by both academic art and the divergency of a few marginal great works) from one present to another; from a present of celebration, of representation, to a present without double meaning, without hidden depths: a present which has no meaning beyond itself, which is simply there.

No one phrased it better than Baudelaire: "The life of antiquity was much given to *representation.*" It is true that he added, "It was made above all for the pleasure of the eye," thereby weakening his phrase. For the pleasure of the eye existed in Baudelaire's day for the crowds which jammed the Tuileries to listen to music as much as it did for the crowd that once surrounded the palaces of the Doges and the Ambassadors in Venice. And even for modern painting there would be nothing but that "pleasure of the eye." The only difference—in truth an immeasurable one—springs from the fact that classical painting presents something which is itself already on display; the image is paired; it stands for an image which itself acts as a sign. By this I mean that the image painted by Carpaccio is the symbol of a figure which already functions as a symbol: it is not a mere matter of a sixteenth-century ambassador on a

visit to Venice but of the hero of a long-established ceremony, a hero already decorated with insignia which the painter has simply to paint: the image on canvas and its model in life are plates inserted into a text, as it were, whereas in modern painting—if a chronological milestone is needed, let us say from 1863 onwards—the image is no longer a full-page illustration; it is no longer backed by a text, the only text being that of its visual character.

Mythological scenes offering several levels of implications for learned interpretation; still lifes in which each element represents one of the five senses; battles in which Louis XIV wears the mask of Alexander; dramatic or psychological allegories going as far as those physiognomical drawings of Le Brun which connect humanity with animality, the human eye being that of the dog or falcon; no image without a meaning external and previous to itself, and each of these meanings a word in a text that accounts at the same time for the intelligibility and composition of the world and for the history of a culture—such is the world, at once enclosed and paired, which Goethe evoked in *Torquato Tasso*. At the Court of Ferrara the garden of Belriguardo is adorned with busts of epic poets (on the right, Virgil; on the left, Ariosto). Tasso, although seeking "what is nameless," celebrates the perfection amidst which he is suffocating:

"Here is my fatherland; here the circle in which my soul prefers to dwell. Here for my attentive spirit each sign is charged with meaning."

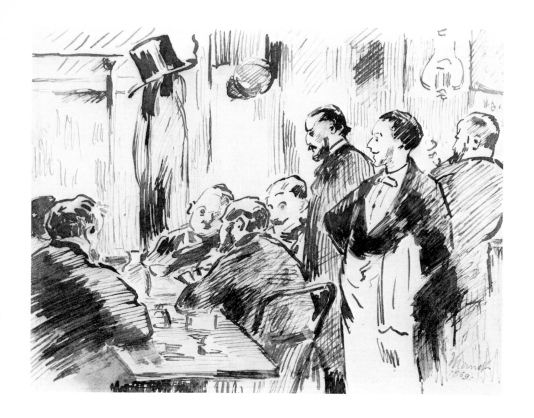

Art and Civilization

So after 1863 it became impossible for an artist to see Venus in the naked woman he was painting; impossible to paint any distinguished figure of contemporary history as Le Brun painted Louis XIV (under the helmet of Alexander) or for that matter a prominent bourgeois in the way the same Le Brun represented Chancellor Séguier. Why did the battle of Solferino, although it could be admired from Meissonier's brush at the Salon of 1864, fail to equal the battle of Pharsalia? Why did it fall short even of Eylau? But Napoleon III himself took good care not to see his own image in the features of the emperor celebrated by Gros and David, and presented by Stendhal in the opening pages of *La Chartreuse de Parme* as the successor of Alexander and Caesar. And, despite the adventures into which he let himself be inveigled, Napoleon III even ceased to consider military conquest and glory as the be-all and end-all of history: he was the true expression of the bourgeoisie, whose genius does not lie in the epic. Napoleon I was the last historical figure who lent himself to epic treatment, literary or pictorial. He was the last military genius; it was sensed that his like would not be seen again; that with him history as action and legend was reaching an end, and that after him would begin an entirely different era, progressive and anonymous at the same time, and which, whether bourgeois or working-class, would have production and consumption as its aim. (When he dreamt on Saint Helena of what he might have been had he won at Waterloo, Napoleon could see himself only in the role of a bourgeois sovereign visiting the European countries like so many peaceful estates.)

Edouard Manet (1832-1883). Paris Café (Café Guerbois?), 1869. Pen and ink (11⅝ × 15½″) Fogg Art Museum, Harvard University, Cambridge, Mass. Bequest of Meta and Paul J. Sachs.

All repetition, said Marx, transforms drama into comedy. The judgment scarcely holds true for the classical world, where, in a certain sense, everything is repetition, and to which belongs the *coup d'Etat* of the 18th Brumaire which first brought Bonaparte to power. But Marx's judgment became true for a history which henceforth was progressive; in which repetition could have only negative significance: it held true for the 2nd of December, 1851, when Louis-Napoleon overthrew the republic and proceeded to proclaim himself Emperor as Napoleon III. From then on historical action would no longer be the fresh display of an antique glory, a primitive virtue: for the first time its object would be the management of the things placed at man's disposal. And if socialist regimes have made persistent attempts at artistic portrayals of their leaders, there is visible proof that they have succeeded no better than bourgeois society, and for the same reason: their ultimate aim is bourgeois, in the sense that it is not epic, unless, like the bourgeoisie, they begin playing a double game and acting in bad faith. The heroic effigy of Lenin is in contradiction with Lenin himself, who was a simple man. That of Stalin or Mao is in contradiction with the truth they served in theory, that truth of which the "cult of the personality" is either the conscious or "objective" betrayal.

The term "bourgeois society" has come from my pen, and the inevitable moment has come to take up the relation between this new painting and that society. To see in the new painting the accuser of bourgeois society is no more satisfactory than to see it as that society's accomplice, although of course the ties between them cannot be denied by pretending that the left hand does not know what the right hand is doing. An irritating problem, which one must beware of skimming over too quickly! The difficulty is that, whereas the bourgeoisie has but a single face, henceforth two kinds of painting are to be found.

There is an art which bourgeois society secretes naturally and acknowledges as its own. And that is first of all—without even mentioning adulatory art—euphoric, anaesthetizing art, which suggests that life is problem-free, without serious situations: boulevard theatre, syrupy sentimental novels, music-hall, genre pictures portraying the small joys of existence. But this society is not always frivolous; its intention is not always to pass unnoticed. It sets itself up, in fact, as being all the more noble and serious for having so many doubts about its legitimacy. Academic art enabled it to see itself as it wished to and could not be: the heir to a tradition of classical beauty, of mythological culture; the instrument of a history of epic stature. From Baudry, Cabanel and Gérome it received its certificates of good breeding; Meissonier, Vernet and Flandrin guaranteed that its glory was not unworthy of the past. Bourgeois society founded museums, frequented antique dealers, amassed collections to bolster its faith in its own antiquity while transmitting to the art of the imaginary and of harmony its own artificial respiration.

On the other hand, anxious not to make bad bargains, it demanded an art that was well made; made, that is, according to the rules, as a warrant that the painter had learned his trade (at the Ecole des Beaux-Arts), and carefully

Louis Beroud (1852-1939). At the Louvre, 1883.

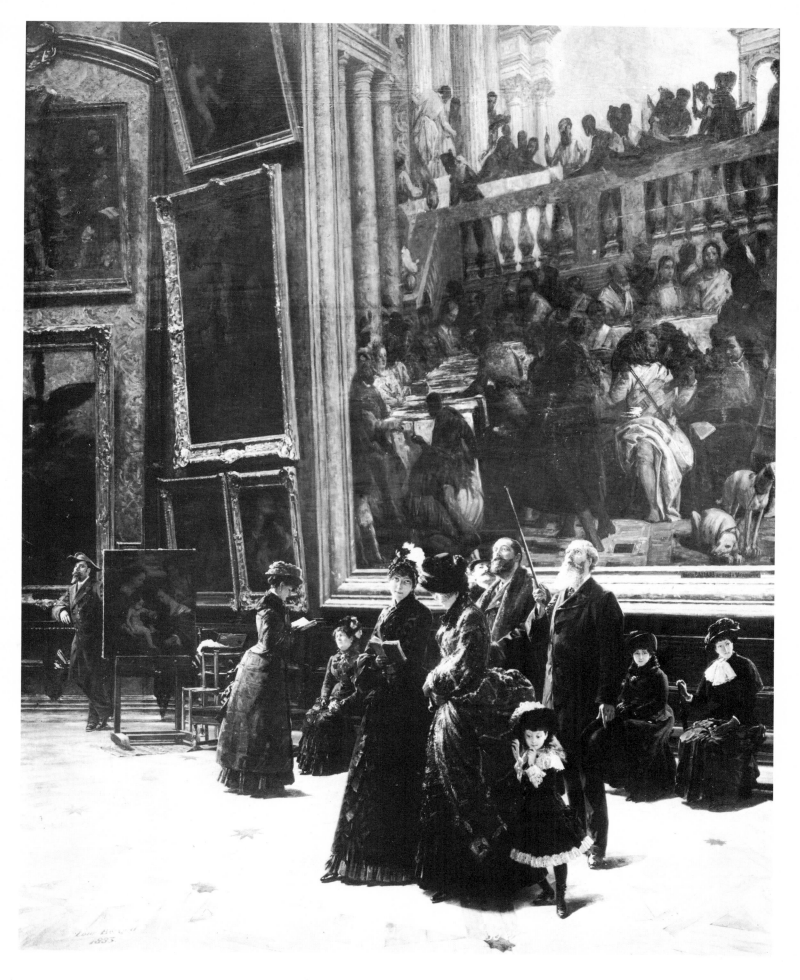

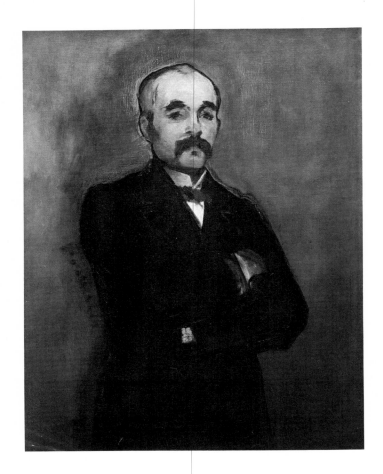

Edouard Manet (1832-1883). Portrait of Clemenceau, 1879-1880. (37 × 29 1/8") Galerie du Jeu de Paume, Louvre, Paris.

executed, finished in the smallest details and thereby justifying the purchase price. This was the society that reproached Whistler for asking 200 guineas for a landscape done in a few hours, to which the painter (the same who said of paintings cited against him that they might have been finished but in any case had never been begun) could retort that the sum in question was payment for knowledge acquired in the course of a lifetime.

In breaking with this art which was simply or sublimely idealizing, the new painting cannot be suspected of complicity with the bourgeois order, despite so many neo-Marxist or "Marcusian" insinuations! Must we then see in it—as we are invited to by analysts who start from the same sociology but happen to like this painting—a denunciation of that bourgeois order? We need not take this line any more

Reception at the Home of Princess Mathilde, Rue de Courcelles, Paris. Print published in "Le Monde Illustré," 1867.

than the other. And we must ask, in the first place, is it the bourgeois structure of society which is under debate or its ruling-class status, whatever its nature? Idealizing art, euphoric art, is the official art of every class which aims at keeping its power: Stalin's Russia and Mao's China provide the same proof as the France of Napoleon III. Academic art no doubt is a response to a particular complex which in fact is that of a bourgeoisie uneasy over its own legitimacy. But such art expresses the sickness, not the health of that bourgeoisie. For if there is a bourgeois lie there is also a bourgeois truth, a bourgeois genius; and the new painting may have some connection with it.

For this genius, precisely, breaks with idealization, the heroic, the past, the imaginary: it is the genius of a lucid energy engaged in the conquest and rational exploitation of the earth; an energy conscious of its break with history, of being the first step in a decisive surge ahead. The Second Empire became involved in military operations which had unequal success and which were celebrated equally by official art; but it was not glory that bourgeois society was seeking. It honoured not the hero but profitability—an anonymous mastery. Paintings such as *1814* and *Napoleon III at the Battle of Solferino* are as far from the bourgeois genius (if not from the bourgeois lie!) as *The Execution of Maximilian*, which demystifies heroic history, the legend of the Prince. And from Ingres's *Monsieur Bertin* to the portraits Manet would leave of Rochefort or Clemenceau, these images having no aim to please, with no symbolic or mythological attributes, represent, like the Dutch portraits of the seventeenth century, a rejection of pomp which is a bourgeois rejection. Between the new art and society there was the essential difference

that art refused the legacy of society's bad faith; but it was of *that* society that the new art was the genius. It shares with bourgeois society that relation to things which, while excluding the sublime, the past and the imaginary, ceaselessly strengthens man's grip on the world.

Undoubtedly, beginning with the advent of bourgeois power the history of art is often one of misunderstood and maligned solitude. But it is with the public, the mass, here intruding for the first time, that the conflict lies, rather than with the values of the new society. Baudelaire, Flaubert and so many others were quite right to see in the bourgeois their enemy. But for them the enemy was the eternal philistine, from whom everything separated them, and not the representative of a class to which they themselves belonged, of a power from which—more or less—they themselves benefited. The salon of Princess Mathilde excluded the philistine, but all those who frequented it were bourgeois.

Coincidences of dates tempt us to range under the same banner everything which, at the same moment, constitutes *movement*. For 1863 was also the year of the general election which, in Paris, the department of the Seine and all the large cities, brought success to a finally united opposition. And 1863 was, furthermore, the year in which a working-class party was formed in France, although no workers' candidate stood for election. In 1862 a French delegation was sent to the world's fair in London. In 1864 the *Manifesto of Sixty* was published in Paris, while in London the International Working Men's Association was founded, with a proclamation drawn up by Karl Marx. But it must be pointed out that the opposition was scarcely less bourgeois than the

government: it was claiming its property back from the regime—the bourgeois property of liberty.

Would a more radical denunciation be sought, going further than bourgeois opposition, to be followed by a certain kind of painting? Such a development is no easier to discover in the realm of politics than in that of the plastic arts. For one thing, working-class opposition in France was not conceived outside the context of the bourgeois world. It was to the union of social classes against the imperial dictatorship that the *Manifesto of Sixty* appealed: "The political significance of working-class candidacies would be to strengthen, by complementing, the action of the liberal opposition. That opposition has demanded the necessary political freedoms; the workers would demand the necessary economic reforms." To be sure, the drafter of the proclamation of the founding of the International did not seem to look at the problem in this way. "The economic emancipation of the workers," wrote Marx, "is the great end to which every political movement must be subordinated *as a means*." But these three crucial words disappeared in the French translation, the republicans having seen in them a manœuvre to divert the workers from the political struggle against the Empire.

Might "social" painting go further than the workers' movement itself? Through Daumier it denounced the acts of a police, a regime, or a perhaps irremediable poverty lived in pain or anger with no hope of change. And Millet, who depicts the ancestral peasant, not the victim of a specific condition, does so with something approaching serenity. (Moreover, it is practically never the worker, the victim of capitalist concentration of production, who is represented;

it is the peasant, the artisan, the employee rather than the manual labourer.) Courbet, the only painter who was socially revolutionary—and who would pay for his participation in the Commune by death in exile—smiled at Proudhon's explanation of his *Stone-Breakers* and said quite simply that he painted what he saw. (In a similar vein Géricault railed at those who saw in *The Raft of the Medusa* a "patriotic" or "subversive" brush.) And even if we give to this painting a politically revolutionary meaning which it doesn't possess, a painting that corresponded to such a definition could not represent a pictorial revolution which, shutting itself up in its own language and plumbing that language's depths, very nearly nullifies the importance of its subjects.

The maxim *nothing but the truth*, the reduction to a world in the grip of labour,

forms between the bourgeoisie, the proletariat and painting an essential bond of the spirit—of civilization. Compared with the *Odalisques* of Ingres, the elegant women of Manet, the working-class women of Daumier and the peasants of Millet and Courbet are all on the same side; and the working-class has no other desire than to benefit from the goods and the gods of its masters. But if the "triumphant bourgeois" and the innovating painter at first shared a common vision of the world, the differences between fields of interest and between means of expression implied and aroused an opposition that rapidly became relentless.

◄ Jean-François Millet (1814-1875). Woman Carding Wool (detail), 1863. Private Collection.

▼ Edouard Manet (1832-1883). Woman with a Black Hat: Portrait of Irma Brunner, the Viennese Lady, 1882. (21⅝ × 18⅛″) Galerie du Jeu de Paume, Louvre, Paris.

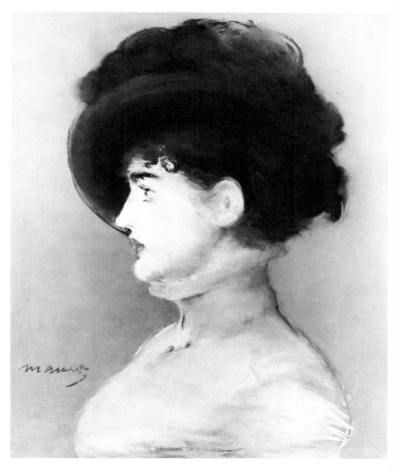

This vision of the world, basically, was but an empty frame: it was left blank. The new painting was joined to bourgeois society by a noncommittal tolerance: that society was one of non-interference with doing or seeing; it did not judge the act or the perception by any transcendent value, by any value outside reality. The only law was that each must work on something that could be produced by work; man was created in order to transform a natural resource into a product of his labour. But it goes without saying that the labour of painting, itself also relative to *what is there*, leads to a manufactured product so different that it becomes unassimilable and finally hostile: the profitable, useful, quantitative value of social labour is challenged by the useless, qualitative value of artistic labour. Even when the reality of Manet, Monet or Renoir is that of bourgeois happiness, it sends forth what life touches lightly in passing, without paying attention; it makes Sunday recreation the law for the whole week; it turns the commandment of God inside out. The play of light on the waters of La Grenouillère, the iridescence of the smoke in the Gare Saint-Lazare, the gleam of a little red wine at the bottom of a glass hold all the meaning of life and make nonsense of life's other meaning. The society which has permitted the artist to gaze at whatever he wishes, for lack of something better to offer him, expects from that gaze at the very most the frivolous ornament of its more serious existence. And it will even agree that art by definition should be useless: Ruskin's thesis is a concession to the bourgeois vision.

Claude Monet (1840-1926). La Grenouillère (detail), 1869. The Metropolitan Museum of Art, New York. Bequest of Mrs H.O. Havemeyer, 1929. The H.O. Havemeyer Collection.

Edouard Manet (1832-1883). Asparagus, 1880. (6¼ × 8¼″)
Galerie du Jeu de Paume, Louvre, Paris.

To lay claim to the useless is, for the artist, a defeat. But everything changes when art claims a monopoly of what is truly useful, and asserts sovereignty. Being liberal, society cannot defend itself by gagging the artist; but it will refuse to listen to him, or rather it will show itself to be naturally deaf. In that sense, the energy of painting disturbed this world of honest toil like an accusation infinitely more profound than any political revolt. From being content to plead for the right of the useless to exist, painting went on to assert itself as an autonomous form of work, to set up for an absolute value. And it was to go even further, for to base its dignity on the autonomy of a technique was to bow once again to the bourgeois social order of the division of labour: a form of labour cannot be an absolute value. Painting would therefore try to call forth by its pure presence what the civilization of work and even the painting of free observation lacked: the fullness of being. "Listen, just between ourselves, if there is no God, even so there

exists, here or somewhere else, something that resembles him, whose presence we feel at such moments." The painter's gesture alone would soon possess the illusion of evoking what Van Gogh (who addressed the above lines to Theo) or Gauguin felt in the moment, the object or the dream.

Within the same moment and frame of mind it is inevitable that the diverse activities of man should be united by many bonds; but these relations, when they can be grasped, often appear as relations of complementarity or opposition. What has been said of the relation between painting and bourgeois society can provide a key to other comparisons. The moment in which the new painting came into being is the same in which the scientific spirit began to gain the upper hand over the spirit of religion or philosophy.

The disappearance of perspective in painting has been linked with a new scientific spirit for which the geometric models (of the Renaissance) ceased to have value. The new painting, it was assured, resembled science in being, as Zola put it, "analytical"; in constituting "a critique of perception." The study and sketch were seen as the equivalent of scientific observations from which Impressionism thought to infer the laws of the perception of colours. But the laws of impressionist perception (those of Seurat, Cézanne or the Cubists) were the norms of a historical script, of a style which might effectively become common but which in no sense could be applied universally in space and time like the laws of science. Furthermore, the scientific critique of perception ended in a formulation that ruled out any reference to the perceived object: it disputed what was perceived

and aimed at dispensing with it, whereas painting appealed against traditional perception in favour of another, more sensitive perception. And although the new painting was said to go from perception to sensation, that was true only if care was taken not to define sensation in scientific terms. For the painter's task was not to discover the genetically determined "this side" of perception but to create the symbol of an original and fabulous sensation of the world, the myth of the perceived in purity, implicit in every occasion for using the senses.

It is also interesting to note the connections, oppositions or discrepancies between painting and the other arts. It may be asked in particular why the innovating spirit chose painting in which to manifest itself, leaving sculpture and architecture to routine, banality and eclecticism. Finally the question arises why it was Paris alone that received the breath of inspiration...

At the Salon of 1863 Courbet exhibited a sculpture, *Young Fisherman in Franche-Comté*, which inspired a caricature by Cham showing a solidly bourgeois couple in the exhibition hall exclaiming: "Even with sculpture we're not safe. Monsieur Courbet has slipped in that way!" But the change here was a question of subject, of a sculpture answering the call of the realist programme; it was not a change in style. The beginning of that change was to be found in Carpeaux, who exhibited in the 1863 Salon, along with the bust of Princess Mathilde, a figure group of *Ugolino and His Children*. The novelty of a work like *Ugolino* may be gauged by the resistance it encountered: the State refused to pay for the execution of the work in marble, and it had to await a private commission in 1867. And Rodin, whose first modellings were corrected by Carpeaux, began in 1868 the

series of male portraits preceding the series of busts of women: the *Man With a Broken Nose* had already been submitted in 1864 to the Salon, which had rejected it. A common excitability, at the service of grace in one and force in the other; that rippling and bristling which animates surfaces; a heightening and accenting of details; the mobility, the freeing of forms—in all that surely there is an analogy with the pictorial researches of the period, a pictorialization, as it were, of sculpture. Carpeaux's subjects, however, remained academic, and the models of Rodin are classical antiquity and Michelangelo: he is infinitely closer to Delacroix than to Manet.

It was to painters—Daumier and above all Degas—that sculpture would owe its most modern expression. In any case, the stylistic contribution of Carpeaux and Rodin would scarcely be given a hearing: as a whole, sculpture belonged to the party of order, as against that of change.

This "rout," as a chronicler of the time called it, did not pass unobserved. Zola, in an article published in 1868, explained the backwardness of sculpture by historical reasons: sculpture had been so closely tied to the nude that it was indeed difficult to emancipate it, to "reconcile it with modern times," to make it the "daughter of our civilization." To sculpt modern man in his black dress coat, his suede gloves and his polished patent leather boots was more difficult than to paint him; and there does not seem much conviction in Zola's promise that "the naturalist sculptors will be the masters of tomorrow."

Some years before, Baudelaire had given quite another reason for the inferiority of sculpture. "Brutal and positive like nature," he

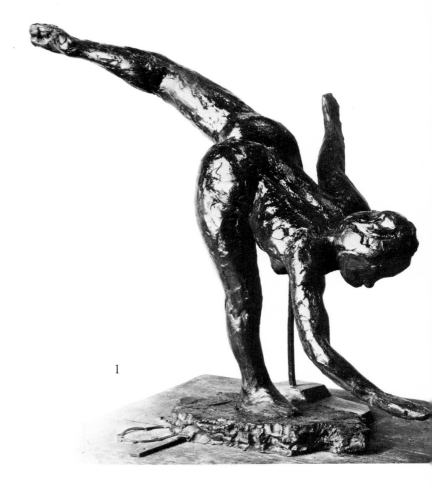

1

Edgar Degas (1834-1917):

1. Grande Arabesque, Third Time (Second Study), 1882-1891. Wax statuette. (Height 14¼″) Louvre, Paris.
2. Galloping Horse. Bronze statuette. Louvre, Paris.
3. Dancer Holding Her Right Foot in Her Right Hand, 1896-1911. Bronze. (Height 17¾″) Private Collection, Basel, Switzerland.

Honoré Daumier (1808-1879):

4. Ratapoil (i.e. superpatriot personifying Napoleonic militarism). Bronze statuette, 1850. (Height 18⅛″) Louvre, Paris.

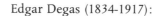

wrote, "[sculpture] is at the same time vague and impossible to grasp because it shows too many aspects at once. It is in vain that the sculptor tries to adopt a single point of view; the spectator who moves around the figure can choose a hundred different points of view, except the right one...A picture is only what it means to be; there is no way of looking at it other than on its own terms. Painting has only one point of view; it is exclusive and despotic. The expression of the painter is therefore much stronger" (*Salon of 1846—Why Sculpture is Boring*). Hazardous judgments, no doubt! It remains no less true that the painting, a *cosa mentale*, is peculiarly adaptable to the designs of the spirit. A picture is not only what it means to be. But painting can be what it wishes to be more easily than sculpture.

And of course architecture is even harder to budge. With the help of industrial development the middle of the nineteenth century was everywhere an era of builders, but it was still dominated by classical models. It was in architecture that the split was most apparent between the blueprint which the bourgeoisie lucidly followed on one hand, and its alibis, lies and illusions on the other. It required its architecture, furnishings and decorative arts to drape the reality of new materials and industrial machinery with a finery untainted by vested interest: opposing art to technology salved the consciences of both those who exploited technology for purely practical ends and those who exalted art without possessing the intelligence of the technological world. The transformation of Paris by Haussmann testified to the classical

Victor Baltard (1805-1874). Metal frame structure of the Central Markets (Les Halles) in Paris, 1854.

taste for the straight line, symmetry and the "fine contour"; but it was a taste adulterated by the ostentation of upstarts. Classical references and decorative pomp mingled in an ever-broadening eclecticism was, in Paris, the style of the hour; it may be seen in Lefuel's additions to the Louvre and especially in the Opera built by Charles Garnier, the foundation stone of which was laid in 1862 and the plan displayed at the Salon of 1863. Harking back to his polychrome restoration of the Aeginetan frescos, Garnier mixed gold, bronze, marble, stone and elements borrowed from classical antiquity (caryatids, rostral columns, mosaics) with elements originating in the Renaissance and the eighteenth century (rustic work, dogtooth mouldings, pediments, consoles, fireplaces).

True, an architecture of metallic structures without decoration whose open-work admitted light (and which might be considered analogous in spirit to the new painting) was beginning to spring up in opposition to traditional architecture: the Central Market (Les Halles) by Baltard, the interior of the Gare du Nord (1863), the public reading room by Labrouste in the Bibliothèque Nationale (1868). And the role of Viollet-le-Duc has to be stressed. He replaced the idea of artistic beauty by the idea of adaptation to function (better achieved, in his view, by Gothic than by Greco-Roman architecture); he denounced the confusion between architecture and decoration, overcame the opposition between art and technology and justified the use of industrial materials. Thus, more than anyone else he opened avenues to the future. In his article "Style" in his *Dictionnaire raisonné de l'architecture française* (1854-1869) he declared that "beauty and style do not reside in form alone but in the harmony

between the form and a purpose, a desired result."

And in that fateful year 1863 there was a Viollet-le-Duc affair just as there was an affair of the Salon des Refusés. In a School of Fine Arts under the domination of the Institute, utterly subject to tradition, the appointment of Viollet-le-Duc as professor of art history and aesthetics, imposed by the Emperor and tied to a whole string of reforms, had a clearly revolutionary significance. An intrigue led by Ingres was worked up against him; the students prevented him from speaking; he resigned. Taine replaced him; the Emperor gave up the idea of reforms—a backdown infinitely more fraught with consequences than it would have been for painting! For painting to exist it is almost enough for it to have been conceived; architecture, on the other hand, requires commissions from the State, powerful private bodies, wealthy clients. The market, therefore, would remain in the hands of traditional architecture. At most the cake would be divided; for example, if the metallic structures of the interior of the Palace of Industry (1855) are the work of an engineer it was an architect (Viel) who was commissioned to carry out the external camouflage. Whatever happened, fine architecture would continue to be distinguished from merely utilitarian building.

It remains to determine the reasons for this particular choice of place. Why was Paris so exclusively the stage for this revolution of art through painting?

"This art—French painting after Manet, superficial open-air painting which succeeds the in-depth painting of the great period and brilliantly prefigures the end of painting—could only be at home in the Paris of Baudelaire, in the nerveless, decadent atmosphere of the cosmopolitan capital..." The chapter of Spengler's *Decline of the West* from which this passage is drawn has always made me wonder, both because it presents what existed as replacing what might have been, and—contradictorily—because it regards as natural, as explicable, what remains after all partly in the realm of chance, of the "throw of the dice."

Spengler might well have regretted that the Faustian German soul had not triumphed by its depth over that superficial, bright and insubstantial painting. Yet he recognizes its decisive spirit and admits the formal uncertainty of Hans von Marées or Böcklin. He thinks, nevertheless, that Leibl succeeded where Courbet failed, the metaphysical browns and greens of the old masters becoming once more the complete expression of an inner event; that Menzel had brought to life a fragment of Prussian rococo, Marées a fragment of Rubens, Leibl something of Rembrandt's portraits. But the point is precisely that nothing can bring anything else back to life: the guillotine blade of French painting fell forever on what had gone before. Apart from that painting, what was there? It is tempting to reply: nothing, if not what prepared for it, what chimed in with it.

What prepared the way for it was the English landscape school. It was from London that Chateaubriand wrote in 1795 the letter in which he advised artists to draw landscapes "from the nude." In a general way, English painting was closer to Dutch landscape painting than to French art with its hierarchy of genres, at whose summit history painting sat enthroned, uncontested. At the beginning of the nineteenth

century the tourism of archaeological and picturesque sites had brought the watercolour into fashion, thereby furnishing a decisive instrument to the art of the rapid impression. It was thus no accident that Constable was the first great painter whose greatness rested solely on landscapes. In 1824 his *Hay Wain* was exhibited at the Paris Salon, and Delacroix (who admired equally the watercolours of Constable's friend Bonington) greeted him as "the father of our French landscape school." Constable's pictures may be the first examples of a painting in which the object takes the place of the style; where dignity, majesty, fullness come from any and all things in daily life, where the evidence of order does not depend on a composition. The simplicity of what is there suffices, along with a kind of primal breath giving its respiration to the visible world: in the wonderful oil sketches which he kept back unexhibited as well as in the large canvases he did exhibit, and whose influence was immediate (bright colours thickly applied, tiny streaks of pure white added with the palette knife, and an almost Cézannesque build-up of brushstrokes), we see and feel those "dews, breezes, bloom and freshness" of which Constable spoke.

As for Turner, except for his undoubted influence on Victor Hugo's drawings through the album of engravings published in 1835, his effect would be felt only later; not until Impressionism and even the Neo-Impressionism of Sisley and Pissarro could he be recognized as the lyrical precursor of the transmutation of appearances which the French were systematically to practise. It is in Turner that, undoubtedly for the first time, the sun of the painter's eye striking the burning glass of the visible would ignite the fabulous blaze in which forms would melt and be cast into new shapes.

Why did England leave to France the privilege of exploiting such discoveries? Clearly we must seek the reason in that concentration of all the French artists who mattered in Paris, where numerous foreign artists came to join them. But there was also that tendency peculiar to the French genius to transform spontaneous and individual discoveries, for better or for worse, into a common and carefully thought-

Silvestro Lega (1826-1895). Woman Reading to a Girl (detail), 1875. Private Collection, Italy.

out plan; the perennial penchant for doctrine and school. That the idea put forward by talent (or genius) is virtually inoperative without "logistical" support is proved also by the example of the Italian artists known as the Macchiaioli. For it was in Italy, in Florence, between 1855 and 1860, that the only movement comparable with the French movement arose: the canvases of Signorini, Lega and especially Fattori, hewn out of a few great blocks of colour in a brutal clash with each other, are surprisingly modern, even portending, beyond Impressionism, a kind of Fauvism. But the provincial circumstances which made the appearance of the phenomenon so hard to foresee (the mediocrity of the previous local art, the ignorance of European art, etc.) made the exploitation of the invention impossible.

Doubtless it is not enough to explain the French privilege by invoking the concentration of artists and the faculty of setting up rational theories. There was also a vocation of modernity: it was no accident that the guillotine which settled matters so often in France came down on that side. The proof is that a communal movement did indeed exist in England, but it took the opposite direction. If the Pre-Raphaelites, in certain respects, may be likened to the modernity of French painting, the differences go much deeper than the analogies. Those who signed the initials P.R.B. (Pre-Raphaelite Brotherhood) after their names (Millais, Dante Gabriel Rossetti, Holman Hunt) also rejected the school, the academy: but they did so in order to take a lesson from primitive painting. They, too, spoke of naturalness; not, however, through rejecting all cultural mediation, but by having recourse to a different history, a medieval religious reverie, against a contemporary world which they accused of obscuring the natural. They too painted in bright colours, and even practised, before Impressionism and less hesitantly than the French painters of 1863, the cult of open air painting; but not in the service of an art of sensation and gesture. The meticulousness of the representation aimed at restoring the object to its pristine, archetypal reality, and wound up in a symbolism of dreams rather than in the analogy of sensations. It was painting which related stories and supplied details, expressed its meaning and came to an end; it formed the strongest, most coherent challenge encountered by the new painting. Those stained-glass knights and angels of the Pre-Raphaelites were the compensating dream of the country that, blackened by coal and steel, had travelled furthest along the road of industrialization. What came naturally to France, on the other hand, was not so much the faculty of choosing as of choosing in favour of that new world in which things were what they became in an act of seeing and working, without any longing for transcendental significance. It was natural to France to be "resolutely modern"; to go forward with open eyes, without looking back.

Painting and the Real

But what was really happening? If certain subjects disappeared it was not true—not true yet—that all subjects disappeared, to be supplanted by the sole act of painting. It was not true that, in Malraux's words, modern painting began at the moment when in a certain portrait of Clemenceau, Clemenceau no longer counted for anything and Manet for everything. More precisely, it began at the moment when the face in the portrait was not that of Clemenceau but simply a face—here and now.

And of course, strictly speaking, it was not a beginning; there are faces by Frans Hals, in particular, which are nothing if not their presence, their immediate visual appeal. But the same phenomenon now became fraught with

new meaning; tended to become law. The law, to be sure, was not without exception; it was not so much a reign being ushered in as a movement taking shape. Painting on two levels of meaning—in which the image betokens a text, comes like an illustrated plate in a text—does not, for all that, reach an end; no doubt it never will. In Manet himself we can follow the checks and setbacks of a movement which as a whole (but only as a whole) took the direction of sensuous immanence. Speaking of *Olympia* Zola was right to stress that there is no answer to the question "What does it mean?" outside

Edouard Manet (1832-1883). Olympia (detail), 1865 or 1867. Etching, third and last state. Cabinet des Estampes, Bibliothèque Nationale, Paris.

45

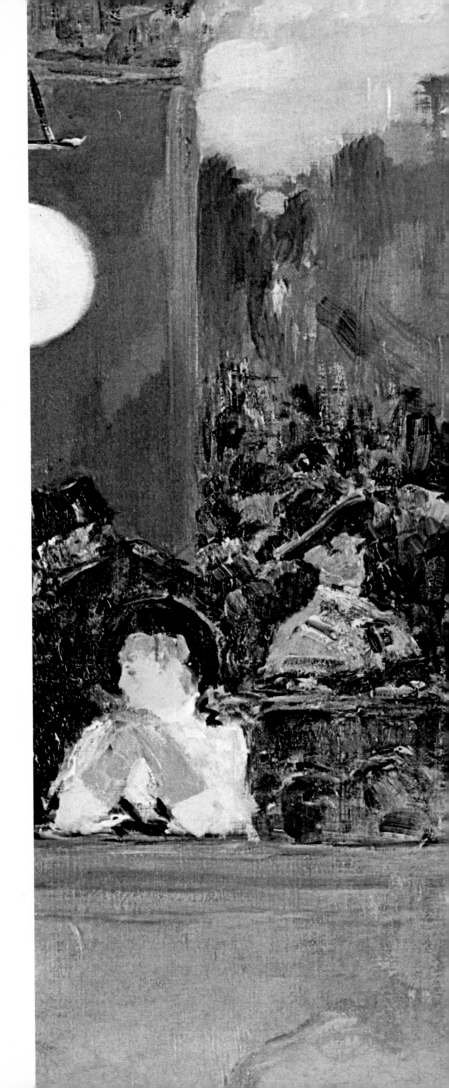

the appearance itself. The accurate answer, however, is not: nothing more than lines and dabs of colour, but: nothing more than a naked woman, a black cat, a servant and a bouquet of flowers which are only what we see of them here and now, and no more. And the apparitions of *A Bar at the Folies-Bergère* and *The Balcony*, female figures who simply stare at us, ask nothing but our gaze in return. But there is duplication in *The Bath*, a still roving reference to the imaginary. In Manet's early years the immanence of *The Racecourse*, of his portraits and still lifes, is offset by the mythological, dramatic or historical meanings of *Christ with Angels*, *The Combat of the Kearsarge and the Alabama* and *The Dead Toreador*. And one of the late masterpieces, the *Portrait of Mallarmé*, opens onto a significance possessed neither by the portrait of Clemenceau nor by those of Victorine Meurent, since the model, whose eye gives out the gleam of a universal attention, is the symbol of the very act that portrays him.

Elsewhere the classical pairing of the image counts for part of the ambition of the work, especially whenever the painting constitutes a gesture of accusation or demystification. *The Execution of Maximilian* implies a meaning, as does David's *Distribution of Eagles* or *The Third of May* by Goya, although the meaning is critical, making history appear as a fundamentally meaningless sequence of failures, reversals and miscellaneous items of news. As for Courbet's *Stone-Breakers* or Daumier's *Massacre in the Rue Transnonain*, their significance (objective or intentional) is full and direct: works of social criticism do not replace images of euphoria by

Edouard Manet (1832-1883). A Bar at the Folies-Bergère (detail), 1881-1882. Courtauld Institute Galleries, London.

46

Drame de querétaro.

Mejia Miramon Maximilien

2

1

H.D.

1. Honoré Daumier (1808-1879). The Massacre in the Rue Transnonain on April 15, 1834. Lithograph. ($11\frac{1}{2} \times 17\frac{1}{4}$").

2. The Execution of the Emperor Maximilian at Querétaro, Mexico, on June 19, 1867. Photograph. Collection Georges Sirot, Paris.

3. Edouard Manet (1832-1883). The Execution of the Emperor Maximilian, 1867. Lithograph. ($13 \times 17\frac{1}{8}$") Cabinet des Estampes, Bibliothèque Nationale, Paris.

4. Francisco Goya (1746-1828). The Shootings of May 3, 1808, in Madrid. Painted in 1814. ($104\frac{1}{2} \times 135\frac{1}{2}$") Prado, Madrid.

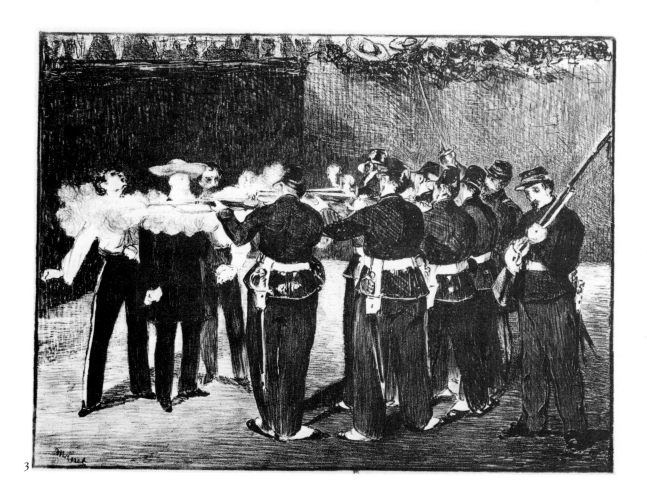

3

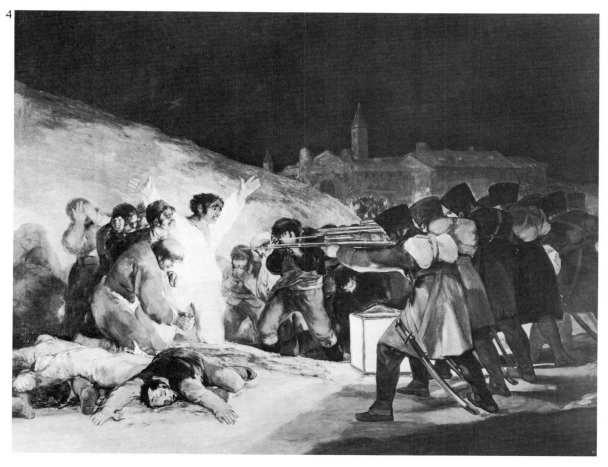

4

images of appearances but by those of a reality which calls up the context of an idea, or at least of an emotion. But however important may be the social criticism discoverable in Daumier, Courbet or Millet, it is obviously not what gives their work its place in the new art. The art of a bombastic imaginary did not give place to an art of accusation; what came into being, despite survivals and deviations from the true path, was an art stripped of any external text. Moreover, the imagery of the period was that of happiness rather than squalor, in tune with the very tendency of plastic immanence. Happiness without idealization, without euphoric trickery; true happiness…Paradises abound, and they are no longer lost or artificial, but paradises of the eye, which can be experienced by everyone. Instant paradises, where the meaning does not lie at the far end of the symbol but at the very heart of what is perceived.

When Courbet spoke of "real allegory" he ascribed to his work a thoroughly classical ambition, suggesting a hierarchy in which *The Painter's Studio, The Meeting (Bonjour Monsieur Courbet)*, or *Proudhon and his Children* stand above *The Trout* and *Covert of Roe-Deer*. The usual method of representation which freighted appearances with what no here-and-now could contain, representation in its traditional ideal sense, remained his preoccupation when he complained, while painting Baudelaire's portrait in 1848, "I don't know how to finish it…Every day he has a different face."

The same concern was shared by Millet, who started with mythological canvases (*Offering to Pan* of 1845) and who remained tied to the museum as much by a chiaroscuro in which shone the yellow-blue dominant of the seventeenth century as by a striving for human expressiveness which he only rarely sacrificed to landscape. In that same year 1864 Millet confided in a statement to the journal *L'Exposition*: "I want the people I represent to seem to have been born into their station in life; I want it to be unthinkable that they should dream of being anything but what they are…It is not so much the things represented that make for beauty as the need one has felt to represent them." Better words could not be found to express what Poussin and Ingres had always thought and said: it is not by presence but by what presence denotes that painting is justified.

Between 1825 and 1828 the Italian landscapes of Corot anticipated in striking fashion the painting of sensuous immanence. The scenes are those of the traditional imaginary, of traditional humanism; the illustrious memories have been chased away along with the shadows. But when painting, under the decisive impetus of Manet, took this direction, Corot drew back; no doubt the young girls of his *Memory of Mortefontaine* are not mythological figures, but no more are they elements among others of a visual moment in time: they do not stand before us, here and now, so much as they represent the essence of young love, something in the vein of Gérard de Nerval's *Sylvie*. And the "sun of soul" which Corot wanted to paint is less that of Monet than of Claude Lorraine: the sun of suns which have set forever…The representational tradition is evidently present in works which, in other respects, are more or less linked with modernity: the modernity of Puvis de Chavannes, of the English Pre-Raphaelites and of Gauguin, who, like Poussin, would soon tell of the lost paradise. But the basic accent of modernity remains no less tied to the absence of all significance outside the

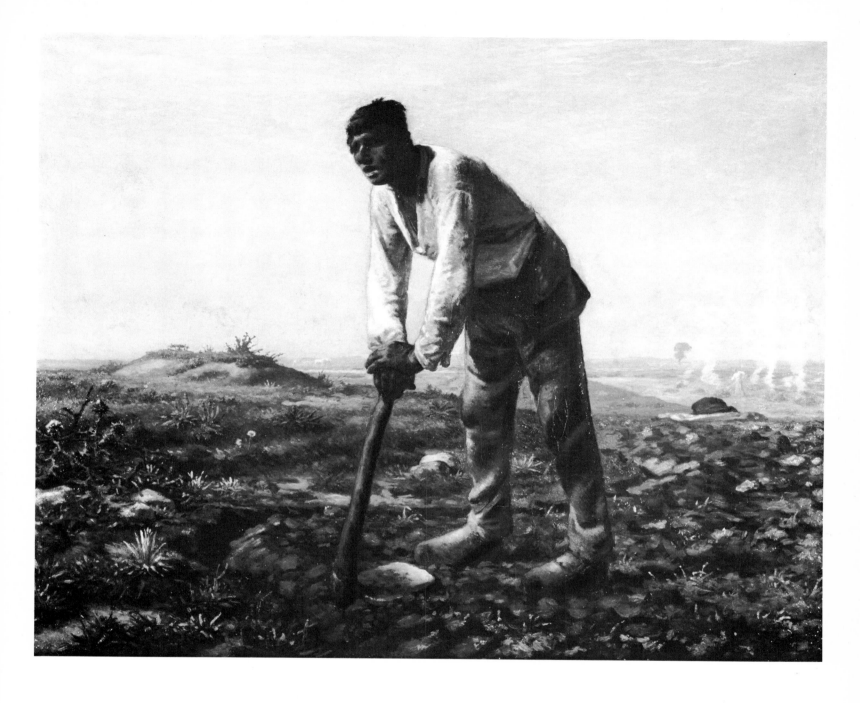

Jean-François Millet (1814-1875). The Man with a Hoe, 1860-1862. (31½ × 39″) Private Collection, U.S.A.

visible; and the representation persisting in the works that mattered was none the less very different from what it had been in the past.

Its aim we have seen: to exclude myth and history (Manet told Antonin Proust that the term "history painter" was, for him, the worst insult) and, at the same time, storytelling and anecdotes. And yet, if the art of the contemporary, the *here and now*, naturally discards those images which always seem to suggest a model,

51

a perfection placed *in illo tempore*, in bygone days, even when they are scenes or persons from contemporary events, it may turn into an art of the brief news item, of the daily past imperfect. Sometimes it did. The drawings of Constantin Guys are only anecdotes; and there is anecdotal material even in the work of Manet and Degas. In opting for the present the new painting became linked with the newspaper cartoon, the fashion sketch and the political caricature. But it encountered or sketched them only in the margin, as it were; they were not what it was basically after.

Or else—and this was the case with Daumier—if the movement took the opposite direction, the result was the same. Daumier sought to take the witness stand; at first he was only a caricaturist, turning to painting only after 1848, and especially between 1860 and 1863, during his leave of absence from *Le Charivari*. In 1849 he painted mythological and religious subjects; after that he went on to modern ones, but a subject of some sort he always had. Here, no longer on the page of a newspaper but on canvas, was the satire of contemporary society, the illustration of a human comedy no less a work of genius than Balzac's, but even more biting, a coconut-shy with a vengeance.

But it is not enough to say that horror or anger transforms these figures of Daumier's into so many masks looming up in the glare of a dream in flames. If all of them are snatched away from anecdote, the rescue is carried out not only poetically but plastically, and in accordance with laws that are beginning to be discovered. Far from standing out against the illusionist's perspective space, all these recognizable figures who bear at least the name of their social category—judges, lawyers, clowns, chess-players, third-class passengers, workers and street-singers—are trapped in the inextricable meshes of the painting, in the tangle of brushstrokes which block all exits; they cannot escape from it, cannot draw breath outside it. The painting fills the picture to the edge, animating it everywhere by its slanting rain, its gusts, its commas; it devours forms, leaving only their contour lines, a flexible skeleton similar to one shown on an X-ray. The result is that the entire human comedy of Daumier can be seen as presided over by that admirable self-portrait in the Phillips Collection in Washington, in which the painter is depicted standing before his easel. In the ochreous and bluish penumbra (still classical?), the white, yellow and green flashes which pick out the shoulder, the hair, or the lower part of the vest are the colours of a palette that has exploded, hurling fragments in every direction.

At all events, in both Salons of 1863, anecdotes and scenes of contemporary manners are generally on the same side as the mythological or historical pictures: the wrong side. *Set To Go Out* by Alfred Stevens is addressed to the same public as *Napoleon III* by Flandrin, *Louis XIV Dining With Molière* by Gérome, or *Hercules Spinning Wool at the Feet of Omphale* by Emile Loiseau. It is not so much that (contrary to what Fernand Desnoyers said at the time, not without profundity, in *La Peinture en 1863*) the anecdote destroyed the inner unity of the true work of art by its external diversity (Millet, Desnoyers observes, had only one subject). For it was not towards the unity of a personal

Honoré Daumier (1808-1879). The Painter at His Easel, c. 1870. (13⅛ × 10¼") The Phillips Collection, Washington.

world that the new painting tended, but towards totality—towards unity no doubt, but the exterior unity of a space encompassing anyone and everything. The anecdote, on the other hand, implies a reading, a title, extended perhaps by a subtitle, which is not, like *Olympia* or *Concert in the Tuileries*, the simple designation of a spectacle but the synopsis of a story, as for example *The Girl at the Well, The Enemy is Dead (Return from the Hunt in the Pyrenees), The Childhood of Charles V, Erasmus Reading*, to cite a few of the works reproduced in 1863 by *Le Magasin pittoresque* and *L'Illustration*. Everything invites us to step out of space and enter the time of the narrative: the image serves as pretext for a text. The reverse is true for the anecdotal pictures of Manet, Courbet, Millet and Daumier: they draw us back into space, towards a text of the senses which is all-sufficing.

The "technical" history of modern painting begins, perhaps, with the portraits by Hals and Goya; but its thematic history starts with landscape treated for its own sake and in a direct manner. As we know, classical tradition accepted landscape only when it was integrated into a composition: as décor for a scene and as idealization. This was especially true in France. David painted a single landscape (the Luxembourg Gardens seen from his prison window); from Ingres (apart from the Roman drawings, of course) we have the three small paintings of Italy; from Delacroix, the Dieppe seascape of 1852 (the other landscapes are his innumerable watercolours and the backgrounds of large paintings).

Eugène Delacroix (1798-1863). View of the Sea from the Heights above Dieppe, 1852. (13⅜ × 20⅛") Private Collection, Paris.

54

Paul Huet (1803-1869). Breakers
at Granville, Normandy, 1853.
($26\frac{3}{4} \times 40\frac{1}{2}$″) Louvre, Paris.

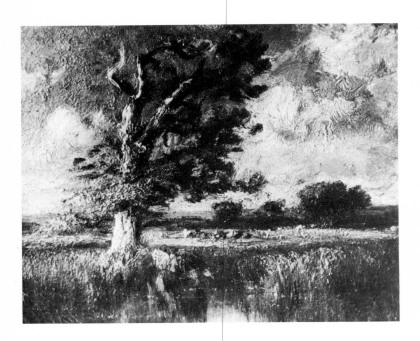

Jules Dupré (1811-1889). Cattle by a Pond. (10⅝ × 13¾") ▲
Present whereabouts unknown.

Théodore Rousseau (1812-1867). Landscape with a Stormy Sky, ▶
c. 1842. (9⅞ × 13¾") Victoria and Albert Museum, London.

There was, to be sure, a "romantic" land-scape, that of Georges Michel and later of Paul Huet, seen through memories of Dutch landscape painting and, especially, through the emotion of the painter interpreting Nature in "fury" or in "majesty" (*Breakers at Granville* by Huet is dated 1853). But, leaving Corot aside, it was the Barbizon school that deserved the credit for a more direct approach, and in particular Théodore Rousseau, the first painter to make a tour of France, on which he passed through Auvergne, Normandy, the Jura, the Vendée, the Creuse, the Pyrenees, Gascony and the Basque country, although he kept his preference for the forest of Fontainebleau.

In his canvases, where the hatchings of the drawing establish, as he put it, the "nervous subsoil" of the painting, and where a spontaneous structuring is occasionally brushed in, Rousseau introduced a delicate and powerful minuteness of detail. His palette doubtless

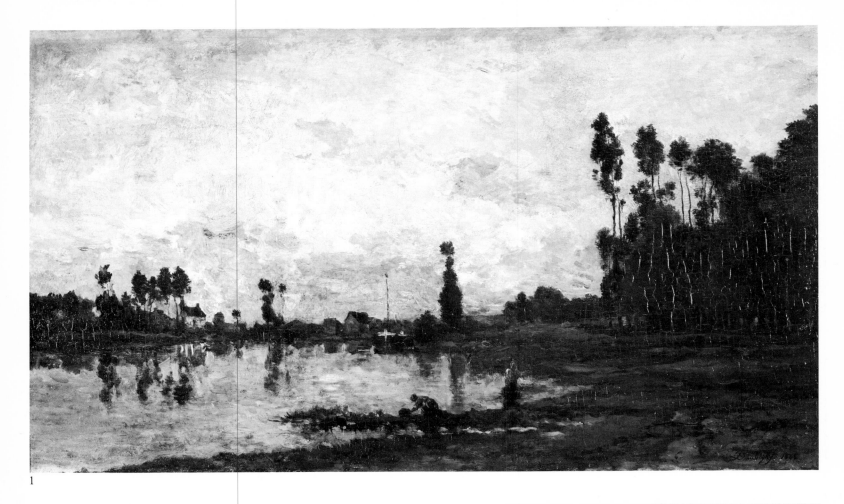

1

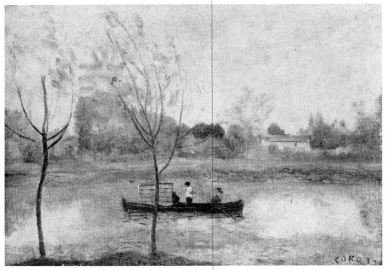

2

3

retained the classical tonality; and in him, as in Dupré, we feel that nature, more than a pretext for painting, is a living refuge: the compensation, perhaps, for the shattered civic illusions of 1848. Daubigny, for his part, is more modern, more exclusively a painter, closer to Impressionism: the first to give up tonality in favour of light, to work exclusively in the open air (in 1857 he fitted out the studio-boat which enabled him to descend the valley of the Oise). He is the first to merit the appellation "leader of the school of the impression." But whatever the differences among its members, there was indeed a Barbizon school. Forerunners of the young men who, around 1862, joined forces at Le Havre (Monet, Boudin, Jongkind), the painters

1. Charles-François Daubigny (1817-1878). Sunset on the River Oise, 1865. (15⅜ × 26⅜″) Louvre, Paris.

2. Camille Corot (1796-1875). Daubigny Painting from his River Boat "Le Botin" near Auvers-sur-Oise, 1860. (9⅞ × 13⅜″) Knoedler Galleries, New York.

3. Claude Monet (1840-1926). The Artist's Studio Boat on the Seine, 1876. (21¾ × 29⅛″) Private Collection, Switzerland.

4. Johan Barthold Jongkind (1819-1891). The Railway Pier at Honfleur, 1866. (21½ × 32″) Private Collection.

4

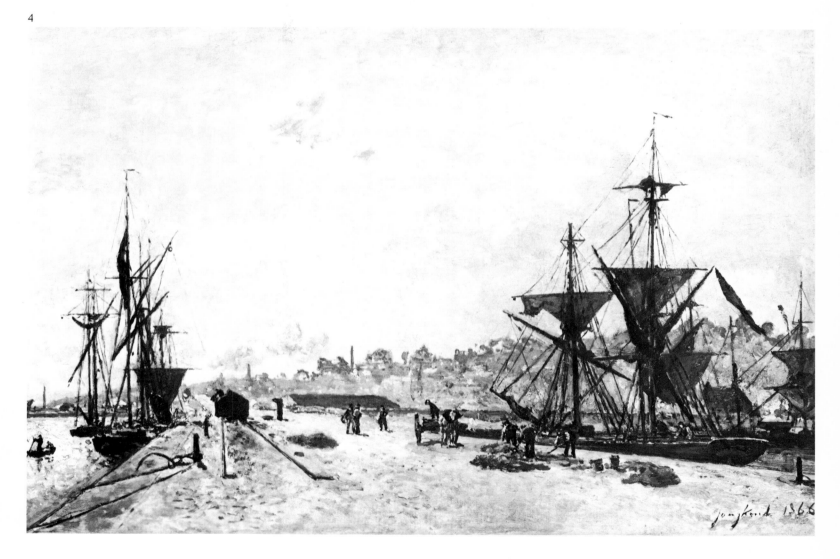

Eugène Boudin (1824-1898). The Empress Eugénie on the Beach ▲ at Trouville (detail), 1863. Burrell Collection, Glasgow Art Gallery and Museum.

Claude Monet (1840-1926). The Beach at Sainte-Adresse, 1867. ▶ (29½ × 39¾″) Mr and Mrs Lewis L. Coburn Memorial Collection, The Art Institute of Chicago.

who formed a group at Barbizon after 1848 together gave a decisive impetus to painting, in a direction followed moreover in other parts of France by Paul Guigou and, above all, Auguste Ravier. Van Gogh was able to say in 1889: "I shall never forget all those beautiful Barbizon paintings; that anyone can do better than that seems to me unlikely, and unnecessary besides."

The moment a painter decides that a landscape can stand on its own, that it needs no justification by a scene in which it will figure merely as a setting, that it is neither a figment of the imagination nor an image from memory; the moment a painter dares to paint directly

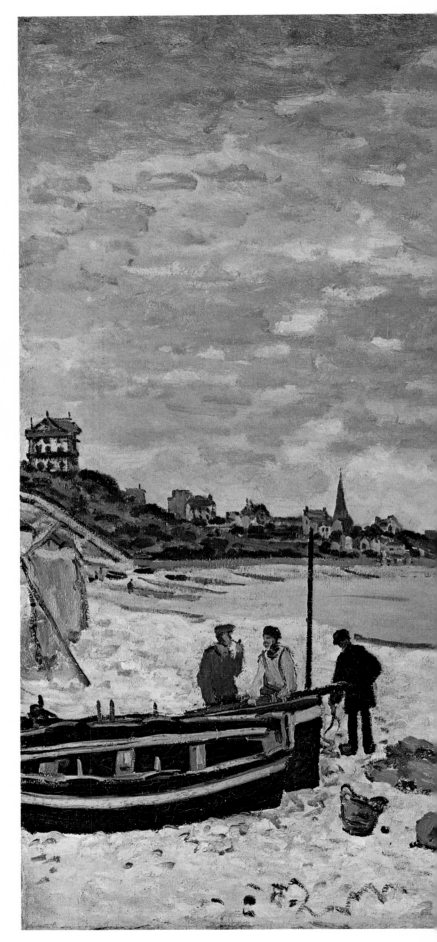

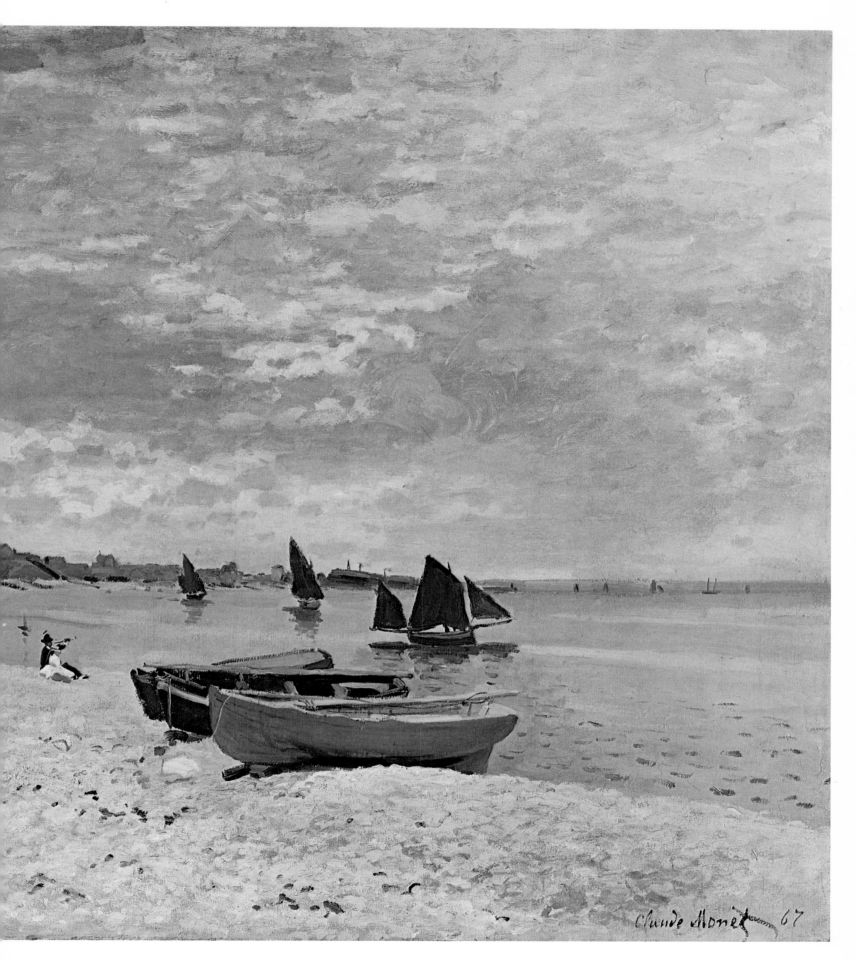

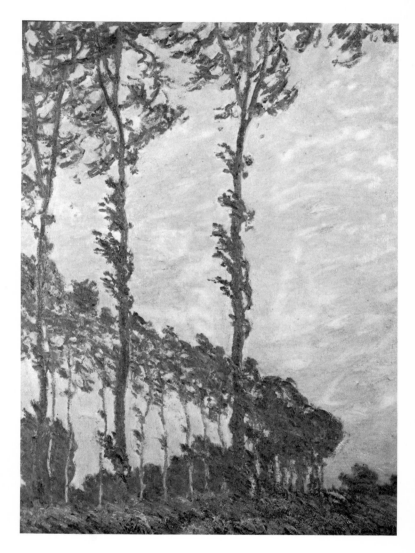

▲ Claude Monet (1840-1926). Poplars, 1891. (39⅜ × 28¾″) Private Collection.

◀ Auguste Ravier (1814-1895). Sunset, Pool at Morestel, c. 1880. (9⅝ × 12⅜″) Musée d'Art et d'Industrie, Saint-Etienne.

from nature in the open air, outside the studio and the conventions of schools, that painter has renounced time in favour of space, exchanged the text for the image. The representation of human figures by Manet—a painter of contemporary manners, of "modern life," in a far truer sense than Constantin Guys—transfers us back into time; but time is handled here like a landscape: it is an appearance of space. Figure, landscape, the terms are interchangeable. Let us not say that the subject disappears, nor even its significance; let us say rather that there is only one subject: the visible, which imparts its significance to each of its manifestations. The visible is both the significance of existence and the subject of the painting.

What disappears, to be specific, is not the identity, the reality of *this* particular image, or its power over us. No, it is not a matter of indifference whether there stands before us a naked woman or a clump of trees, or the waters of a river, or a vase filled with peonies; and our reaction takes the "subject" into account, in a sense. What disappears is all significance, all connotation, that does not come to us by way of the visible—the invisible feudal tenure, as it were, of the image. For instance, that this woman is Olympia, and not Venus; that these waters are the river Oise and not the Ilissos of ancient Greece, is unimportant, despite the possible specification of the fact by the title. What is changed is the relation between the thing maintained—and still effective in its own identity—and the visible order to which it belongs; and it is this modification which makes us believe that the subject has dis-

Edouard Manet (1832-1883). Peonies in a Vase, 1882. (21³/₄ × 17¹/₄″) Private Collection, New York.

appeared. The object has lost its primacy; it is no more than one manifestation of the visible; it is visibleness itself which possesses the power and delegates authority to act on its behalf. In this bouquet of peonies blazes "the absent soul of all bouquets": the sun of which these petals are so many rays.

And yet, despite this equality of all things within the kingdom of the visible, we are responsive to the differences between images, and even to a kind of hierarchy. As a system of exclusion—rejecting, in short, the invisible tenure of the image—this painting corresponds of necessity to a certain order of preferences. It includes a hierarchy based on the aptitude of things to manifest the presence of the sensuous

◄ Claude Monet (1840-1926). The Water Garden at Giverny. Undated. (46 × 32⁵/₈″) Musée de Peinture et Sculpture, Grenoble.

world and be reduced to it. From this point of view the imperfect body of Olympia is more effective than that of Venus or even an Odalisque by Ingres, its imperfection standing as proof of its having been seen and not imagined. A still life is less equivocal than a portrait, which always risks signifying something beyond the visible; but a bunch of asparagus is, after all, a less complete, less brilliant manifestation than those spectacles in which the power of the visible has been called together in its manifold aspects: a racecourse, a ball at the Opera, music in the Tuileries, and, later on, the bar at the Folies-Bergère, the Moulin de la Galette, the waters of La Grenouillère…

While taking pleasure in itself and its methods, painting also enjoys the image it creates; its means of expression are in harmony with the object of its gaze; it continues to be delight, but delight only in what is perceived. Far more than being a painting of accusation, long before expressing through its distortions any disharmony with the reality of this world, the new painting was an encomium of the world. The play of light over coloured shadows, on water, through foliage, on beaches; lovely gardens where children play, where the charming dresses of a season pass by, café terraces where beautiful women put themselves on view: the pleasure found in the means of expression is inseparable from the joy in living and breathing in contact with what gives rise to those expressive means. The world is like painting. And the closer the resemblance, the more worthy it is of painting, the more it nourishes our joy.

All seeing is joy when it is simply seeing. It is from the mind that the trouble comes.

Writing from Barbizon on May 30, 1863 to Alfred Sensier concerning the criticisms that had just been levelled at his *Man with a Hoe*, Millet said that although he saw the drama of "man born to earn his bread in the sweat of his brow" he also saw the "infinite splendours" in which the man is "enveloped": on the horizon of *The Man with a Hoe* lies *Springtime*. The drama is not in what is seen but in what is thought in the presence of what is seen. Hence the distance, the striking difference of coloration between this painting and the literature contemporary with it that is equally covered by the term "realism."

In a great measure the French realistic novel of the nineteenth century springs from the desire of literature to claim back its own property from painting—that property whose limits it so energetically marked out—and Sainte-Beuve was right to study *Un Eté dans le Sahara*, which Fromentin published in 1857, from the aspect of the comparative powers of literary and pictorial description. But description is only one of the elements in a novel, which also sets out to communicate what it thinks of man and society, of which it does not think much that is good. In Flaubert's melancholy, in Maupassant's bitterness, in Zola's "nausea," the descriptive moment is the spark of a pleasure quickly extinguished. It is the instant of accord; that accord to which painting stands as a witness but which literature cannot make its law.

"Realism": no doubt this term, like so many such terms, is poorly chosen. And yet it is hardly possible to find another; and to be understood is sufficient. If an art of distortion from which the real is excluded glimmers on the horizon, it is discernible only at the end of a

long dialectical process. Unquestionably the real would explode, would fly apart at the first shock, even. But initially the aim was to approximate the real, to bring the real closer to the eye. The new painting challenged traditional painting like the truth of a glimpse actually caught as opposed to the illusion of an artificial grouping. For traditional illusionism (Maupassant, in his preface to *Pierre et Jean*, was to apply the term illusionism to every work of art) refers not to the real but to a conventional model of the real. The new painting, however, forgot the museum. (Just as the era of museums was beginning...But the museums, as Zola saw, did not so much assemble models for the painter as gather evidence of the diversity of expression for the spectator or historian. As soon as painting set up for nature the museum erected its monument to culture, as if the culture in question had already reached the end of its development.) The new painting shunned the dimness of the studio, where the models, selected for their conformity with Greek statuary and for their expressiveness, posed in a light that was not the light of nature. (When the model did not fit into the canon of classical antiquity the proper thing was to correct the model. Therein lay the quarrel between Monet and Gleyre, Monet's professor at the Ecole des Beaux-Arts, who was faithful to the manner of Ingres: "Not bad, but too close to the model. You have before you a good fellow of stocky build; you paint him as squat as he looks. He has enormous feet; you render them exactly as they are. All that is very ugly. Nature is all very well as an element for study, but it presents no interest in itself. Style is all that matters.")

The new painting also substituted violent contrasts, without gradations of colour, for modelling by shadows; and the intensity of flat colours for the relief of forms spaced out within the perspective cube. It gave up finicky retouching—a finish that could only be a reconstruction by the mind at the expense of something unfinished and faithful to the act of perception. In so doing, it clearly wished only to come closer to what it took to be true sensation. Thus Constable spoke of *warmth*, Baudelaire (apropos of Corot) of *naivety*; thus Zola, apropos of Manet, spoke of a "window opening onto nature," and Mallarmé, speaking also of Manet, would evoke "the immediate freshness of an encounter."

The thing was to rediscover the sense of sight, in the manner of a convalescent or of a blind man after an operation for cataract. And nothing was more frequent than such comparisons. Ruskin wrote: "The gift of painting depends entirely on our aptitude for recapturing what might be called the innocence of the eye; that is, a kind of childlike perception of those flat spots of colour seen in isolation, without any consciousness of what they signify, as they would be seen by a blind man who had unexpectedly received his sight." And Monet would say "that he would have liked to have been born blind and suddenly acquire the sense of sight, so as to begin painting without knowing what the objects were in front of him."

Is the question one of opening the way to a new perception, truly "unheard-of," or of recapturing a lost freshness? Here the men of the present hour, like Manet, stood opposed to those whose hope had always worn a tinge of nostalgia; those for whom the revelation had already taken place (as the classical tradition thought) but had not been maintained. In Baudelaire's eyes art had to revert, through

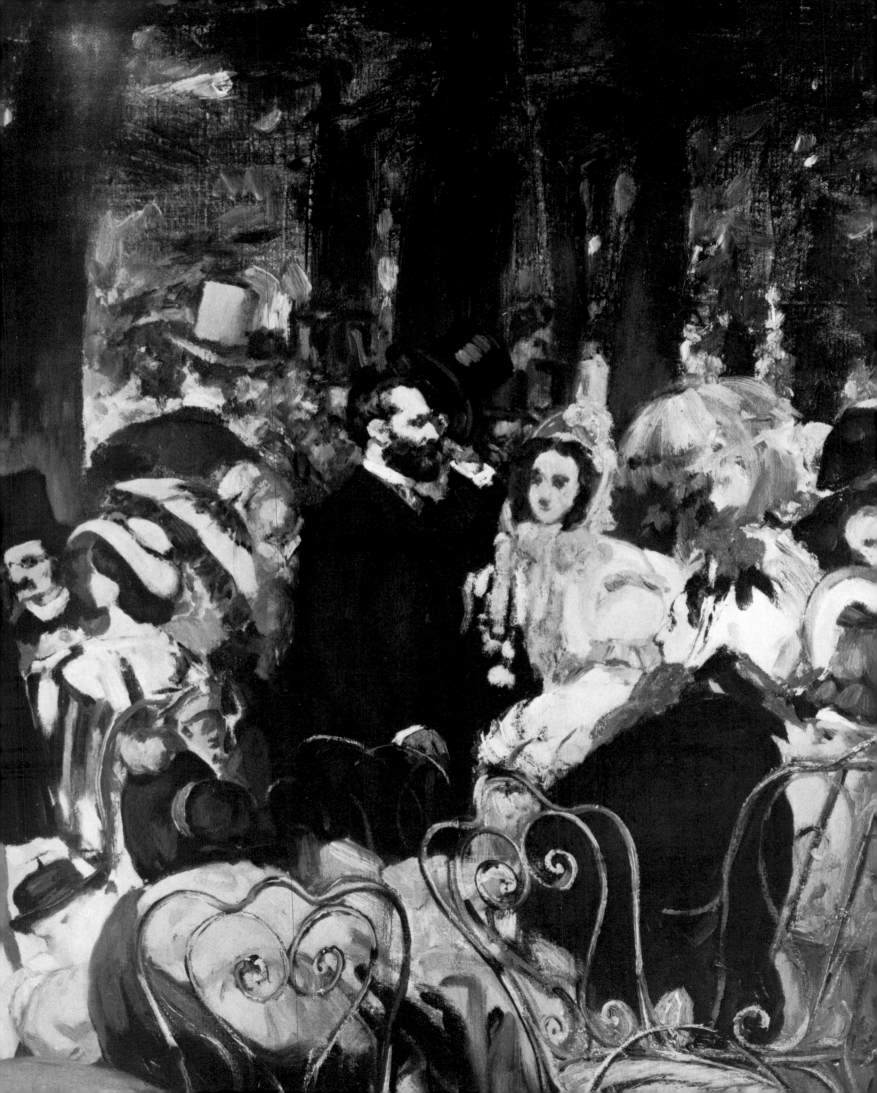

modernity, to a former state, if only that existing in memory: "How the sensations really have come back and been rediscovered!" But in fact it was the immediate which was rediscovered; we exchange an enfeebled present for one that is reinvigorated. In this way the imaginary, mental vision of Pre-Raphaelism, of Puvis de Chavannes, of Gustave Moreau and especially of Gauguin joins the immanent vision of Manet, Degas and Monet, though by a very different route: by way of the mind they remounted, they thought they were remounting, the stream of the sensuous world to its source.

At any rate painting, for the time being, was not engaged in research into itself as painting. It was at home in the world. And

◄ Edouard Manet (1832-1883). Concert in the Tuileries (detail), 1860. Reproduced by courtesy of the Trustees, The National Gallery, London.

▲ A Festival at Montmartre, c. 1862. Stereoscopic photograph (2¾ × 3⅛") Collection Yvan Christ, Paris.

► Auguste Renoir (1841-1919). Le Moulin de la Galette (detail), 1876. Galerie du Jeu de Paume, Louvre, Paris.

Georges Bataille is right (as opposed to Malraux) in saying that with Manet "majesty was retrieved by the suppression of its outward blandishments—a majesty for everyone and no one, for everything and nothing, belonging simply to what *is* by reason of its *being*, and brought home to us by the power of the painting." And Georges Duthuit too is right, in his searching study of art entitled *Le Feu des Signes*, that the question is not one of "the insignificance of things" but of "their utter significance."

Would photography, appearing at the same time as this painting, make it swerve rapidly from its realist vocation? Indeed, there was a sense of perilous coexistence. A picture by Lafaye represents the dramatic session of the Institute: *Painting is Dead!* And in 1862 Ingres

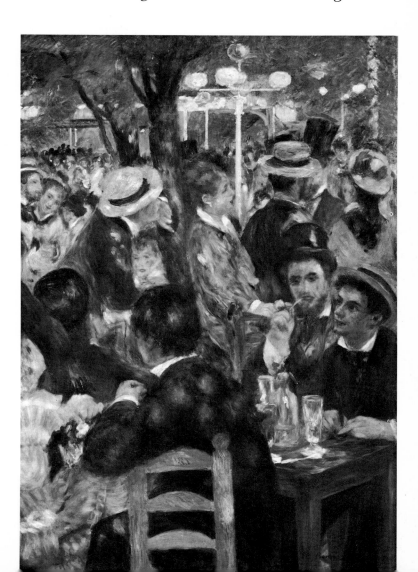

signed the manifesto which declared: *Photography is not an art!* But let us not forget that both Delacroix and Degas were enthusiastic about photography.

At the outset there was a common intention between the two arts, and developments were closely intermingled. Photography imitated history painting while painting still believed in history: Jouvin photographed the troops marching over the Place de la Concorde on the Emperor's birthday, August 15, 1862, and the crowds waiting for the imperial retinue at the Tuileries on January 25, 1863, while at the same moment others were painting the capture of Sevastopol or the pomp of the Emperor's voyage to Constantinople. Photography, in the days when it required a long exposure time, posed and composed just like traditional painting. Later the snapshot and the portable camera would appear simultaneously with Impressionism, which would share the new photography's use of visual angles and unusual layouts. But the subsequent relations are neither of parallelism nor of exclusion; instead there came about a distribution of roles on the same terrain. Photography relieved painting of being an art of portraits and likenesses. It took over from painting its documentary function, the role of a day-to-day historian. And since photography adds nothing to what is already there, whereas painting necessarily possesses an intention with regard to the object it selects, the sign of a harmony or a discord, it was better to photograph than to paint the ostentatious displays of the Second Empire. Painting in such a case could only be painfully grandiloquent, or accusatory (and there are more worthwhile pursuits than accusation).

On the other hand, when photography represents a festival at Montmartre it falls short of the painting, and in the first place of its enchantment of colour. The black-and-white of the photograph called into being a painting more and more highly coloured; and if the instantaneous quality of photography did not give rise to a painting of composition, of premeditated lines, as Ingres and the signers of the 1862 manifesto thought it would, it did provoke by way of compensation a pictorial analysis which would ceaselessly accentuate and define what was originally global and unfocused, and would even seek to anchor chromatic dispersion to linear structures. The painter would work on the fleeting image quite differently than the photographer; his operation differs from that of development or retouching; here the hand works on the eye.

The New Figuration

And yet this painting which divested itself of every artifice so as to approximate the natural seemed obscure, complicated, difficult to read. It reflected the world, but the world it reflected was unrecognizable.

Zola explained this difficulty of adaptation by saying that we are used to seeing only in terms of pictorial convention. And there is no doubt that every new concept put forward, even when it represents progress in approximating the real, has been received at first as confusing and misleading; the same reproach was levelled by Balzac at *La Chartreuse de Parme*, by Sainte-Beuve at *Salammbô*, and by the quasi-unanimity of critical opinion at Baudelaire, Monet and Cézanne.

But the pictorial convention referred to here has all the more force in that it conforms to our normal perception of things. If Renaissance perspective was a cultural choice it expressed a culture that desired to obtain the firmest possible grip on normal perception, and

succeeded in doing so. And in this sense, if the ultimate end of art is seen as being the representation of the perceived image, it is possible to speak of the Renaissance as a step forward. Normally we perceive by following the lines and vanishing points of perspective; we perceive mental images, not painted ones. Now the classical picture—smooth, without visible brushstrokes—gives us the illusion of objects as they exist outside the painting: grapes to fool birds. And as long as painting continued to authorize the identification of the image with the real object there would be at least the start of a mental correction for perspective.

Pierre Francastel puts it very well apropos of *La Grenouillère* by Monet (1869): "The resting points of the composition are lost to view

Edouard Manet (1832-1883). The Races, c. 1864. Lithograph. (14⅛ × 20⅛″) Cabinet des Estampes, Bibliothèque Nationale, Paris.

beneath the scattered touches of colour that reproduce the trembling of light; but, reduced to its general lines, the picture still suggests the famous cubic space of the Renaissance, and we are still gazing through the celebrated open window of Alberti." And he suggests the term "impressionist grid": "The canvases composed in this way seem constituted by the superposition of two images coinciding at a few points, on the model of the colour-printing process which superimposes several series of exposures, using different filters and strictly observing a certain number of guide-marks."

Perhaps, after all, a complete escape from the power of perspective must await the advent of informal art. At any rate, if we still rectify in accordance with its laws, from Manet onwards we do so counter to the most direct suggestion of the picture.

Not that a decision was taken to do away with perspective. It was simply that the pursuit of painting in full light, directly from nature and at the instant of perception, replaced a spatial recession in which objects were ranged at intervals by a flat surface that passed wholly and immediately not for the illusion of an external model but for the internal evidence of colours, lines and brushstrokes whose relations arranged themselves without the eye's having to go beyond the picture surface. As if the space beneath were emptying itself, disgorging the objects it contained, the tide of colour rises and inundates the surface: it throws over the canvas a shimmering fabric without a seam. Colour overflows line, suggests outline, revives shadow. Seen from the front, perspective appears as a discoloration of the world, as a world gradually lost to the eye, whereas here on this flat surface the world is spread out in its entirety. It is the

entanglement, the promiscuity of the colours in *Concert in the Tuileries*, in *Races at Longchamp*, where the black tones do not divide the forms but instead punctuate an unbroken continuity leading into the background. It is the reversible space of *A Bar at the Folies-Bergère*, the ambiguity of the mirror which makes the barmaid come forth out of her own reflection. The diminishing echos of perspective depth turn into the equal intensities of an even depth, its force spread out everywhere, fully assembled at every point.

For there is surely no question of eliminating the background, the essential thing in Manet's eyes: "If the background is opaque, the picture is dead, there's nothing left!" The question is rather to collect the force of the background on the surface of the picture. In canvases by Manet as different in subject and format as *Boating, Asparagus* and *The Balcony*, the background, whether designated as sky, cloth, or interior dimness, appears as the reserve force which dispatches to us the messengers of the visible; it is not nullified but turned inside out. So far from being a destination towards which we travel, and where we can only lose from view the objects it withdraws as our movement progresses, the background is what comes out towards us. In *The Balcony* we do not go from the green of the ironwork to the lamp; we illuminate this green by means of the lamplight; the background is no longer the far distance but the surfacing, the exhalation of the deep.

But it is not always by this overflowing and rising of colour that the reversal is achieved which transforms the background into this propulsive force. The abstraction of the background (analogous to a gold ground) on which arises a harshly outlined form strictly contain-

ing the colour, as in *The Fifer* of 1866, *The Dead Toreador* of 1864, or even *Olympia*, opens a road all the richer in possibilities in that here we can no longer suspect space of containing anything whatever; there is nothing left to correct for perspective. Ingres already showed signs of this modernity when, in the sketch in the Louvre, he supported the body of Angelica by a tall rectangle of pure red; and Degas would remember it.

For the master of the new linear figuration was obviously Degas. With him, space is never the endless empty place onto which the image opens, and which aerates but also imprisons it. Instead, pure colours block up the background, prevent the flight of the image, thrust it back towards us; or rather there is no background, but a colour-shape, a material space within which everything is acted out: the mass of chrysanthemums that leaves the woman only a marginal supporting role (1865); the dark green mass of the wooded hill below which the jockeys stand out (1862); the strip of empty sky filled only with its own colours (beach scene of 1869). And the extraordinary monotype landscapes of 1890 would entirely eliminate the suggestion of space by laying down smoke-blankets of colour without definite boundaries.

However, Degas had a natural preference not for landscapes but for interiors that could be hermetically sealed by walls, floor and ceilings. It was there he extracted new revelations from space. The smooth and slippery floor, at the bottom or top of the image, is the springboard that propels the image or from which it has just rebounded; or else the door panel in the margin is the drawer from which it issues. Space here is not the isotopic medium whose centre is occupied by the image, but a coiled spring, an energy that has its preferences, whose attack may be launched from any point. Or again it is seen to unfold like a screen, all of whose panels are opened at the same time and further multiplied by the action of mirrors.

At all events, with Degas the picture is no longer the motionless rectangle, the ponderous spider's web imprisoning the dead fly; it has the orientation of its directing force; it issues out before us with the movement of a "travelling" camera. And just as the exaltation of the palette reacted against the discoloration of perspective, so, here, the juxtaposing of planes surmounts the confusion of perspective: everything spreads and rises in tiers, in distinctness, instead of being spaced at intervals, in vagueness.

Certain analogies are offered by primitive painting, and above all by the art of the Far East; Manet and Degas himself were known to be acquainted with it through the humble agency of cheap woodblock prints serving as packing for Japanese exports to Europe, and it is clear that the Japanese style of representation exerted an influence no less than that of the purity of the colours. But primitive or Japanese painting is most often an art of aligning successive moments of duration for a narrative purpose, whereas with Degas—a true precursor of the Cubists—it is the appearances and movements of one and the same instant which are juxtaposed: prodigious page layouts, which Bonnard and Matisse would remember, where the unexpected, the impromptu of the instant, is empowered to open up before us the resources of space.

Because this liberation from perspective was far more a matter of instinct than of reasoned choice, it was achieved very gradually, with many interruptions: it only lobbied

Edgar Degas (1834-1917):

1. Café Concert at "Les Ambassadeurs," c. 1877. Etching, aquatint and drypoint, second state. Cabinet des Estampes, Bibliothèque Nationale, Paris.
2. Actresses in their Dressing Rooms, c. 1880. Etching and aquatint, second state. Cabinet des Estampes, Bibliothèque Nationale, Paris.
3. Before the Curtain Call, c. 1892. Pastel. (20 × 13⅜") The Wadsworth Atheneum, Hartford, Connecticut.

3

1

2

painting, so to speak; it did not constitute its legal government.

In the *Venus of Urbino*, the Titian painting which he copied in 1856, Manet did not eliminate perspective; he merely reduced it by the transcription of volumes drawn in dabs, touches and hatchings. In *The Bath (Le Déjeuner sur l'Herbe)* the viewer of 1863 did not find the perspective to which he was accustomed, but today we find at least the suggestion of it. It is not that the ring of principal figures, perfectly

containing the colour, recreates space as the medium of the disposed objects; rather, it creates a foreground behind which we perceive the sunlit clearing, the trees, the woman bending over the flowers. Yet the perspective appears false; the *trompe-l'œil* merely an allusion to *trompe-l'œil*, as if a scene from real life were being played in front of a theatrical décor. In *Races at Longchamp* the surface, "impressionist"

3

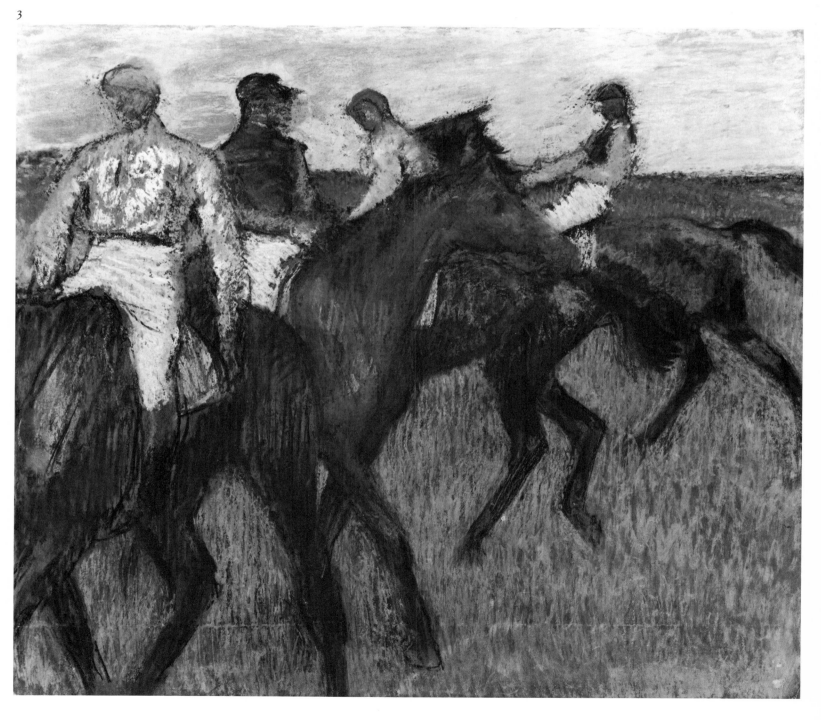

handling of the two lateral masses does not eliminate the vanishing point of the two barriers: the jockeys stand out one behind the other. And the arabesque tracery of *Concert in the Tuileries* has something, as it were, scooped out of its centre. In *Luncheon in the Studio* the intense velvet of the jacket brings the boy in the boater into the foreground while the woman in grey-blue is designated by her size as a background figure. In the *Rue Mosnier with Flags Flying* the figures are arranged in a diminishing scale, the part farthest away being handled with the blue of remote distances. In Manet, though he is the most decisive of painters, there is no end to the number of similar survivals, similar exceptions to the new "law."

The two great masters immediately preceding Manet—Corot and Courbet—visibly herald the liberation from traditional perspective, but they do so by following a zigzag line that was by no means deliberate. Over Corot's views of Rome the thin transparencies of a perpetual pre-dawn glimmer diffuse a light that leaves things no cranny in which to hide. An intenser colour suffices to negate, to reverse distance, as in *The Bridge of Narni* (1826), where the blue of the river in the shadow of the arches seems nearer than the lemony yellow, flows out towards us. And the frontality of certain canvases is striking: *Civita Castellana,* observes Jean Leymarie, anticipates Cézanne; the water painted in segmented strokes, the boulders of the river-bank, the trees, the overhanging rock form a single fabric without a seam, punctuated by a colour that does not divide objects from each other but unites them. A picture like *Rosny-sur-Seine* (1844) seems—almost like a Douanier Rousseau—to have been painted before the discovery of perspective (and there is

that "primitiveness" too in the limpidity of his views of La Rochelle).

But around 1850 Corot, reintroducing softer values while replacing sharp pen strokes by grisaille in the drawing, simultaneously recaptured the suggestions of the past and of remote distance: we have already mentioned *Memory of Mortefontaine* (1864). That was not his last word, however. In *The Bridge at Mantes* (1868-1870) or *The Belfry of Douai* (1871), what we find far more important than the vague suggestion of perspective is the unity which, as in Manet's *Bar at the Folies-Bergère*, comes from the reversibility of planes: the unity of a space that is no longer the medium in which bodies dwell in distance, but standing water filled with breathing light.

As for Courbet, he may appear more attached to the "great tradition" than to the new manner by his Caravaggesque shadows, his limited and rather dark colour range, the massive prominence he gives to certain forms thrown vigorously into relief, and above all by his grand design of *real allegory*, which invests pictures like *The Painter's Studio* with a significance as commanding as that of the great classical compositions, except that the myth—as it appears in *Woman in a Podoscaph* (1865), his "modern Amphitrite"—is resolutely sought in the forms of the contemporary universe.

But these landscapes rarely possess a central vanishing point. In their frontal presentation they have the aspect of a frieze raising up the visible like a wall: the long bar of the waves in the sea-pieces, the crest-line of the view of *Saintes* (1862) or of the rocks of Franche-Comté, the black, white and red forms jammed together like building blocks in *A Burial at Ornans*. (Théophile Silvestre keenly observed the "defect,"

the breaking of all the rules in the latter composition, the heads in the rear standing out too much and coming forward into the foreground, etc.) And if, in *A Burial at Ornans*, as in the cliffs of Jean Dubuffet later on, there remains a narrow strip of sky, elsewhere everything is filled to the brim: a forest interior like *The Shaded Stream* (1865), or a snowscape, has no more background than a bouquet of flowers or *The Trout*: these forms are themselves living, breathing space, just as in other canvases, the seascapes for instance, the emptiness of space becomes a substance which it is unnecessary to delimit, to occupy, in order to make it visible. (And some of his brighter pictures—like the *Girls on the Banks of the Seine*, the study for which, made in 1856, possesses a modernity that impressed Matisse, who once owned it—ushered in open-air impressionist painting.)

Delacroix admired Courbet but found *The Painter's Studio* "singular." It is especially so, he observed, in that the landscape which the artist is painting gives the effect of a "real sky" in the middle of the picture. Ingenuously, Courbet hit upon the symbol for modern painting: it is *painting*, and rules out all confusion with real space, with the "real sky." And it is precisely on this condition that it functions like the real sky.

The gradual effacement of perspective suggests that the image is no longer a distinct unit including its own centre and boundary. Because it no longer has any vanishing point the image can escape on all sides: there is no longer any reason for it to stop. Filling the frame to the border it no longer has any border. In *The Valley of the Loue* by Courbet the enormous boulder squeezed against the left-hand margin seems to continue out of the visual field; in *The*

Trellis the invasion of flowers drives the young girl's face towards the edge of the picture; in *The Irish Girl*, in Stockholm, the spreading of the chevelure seems as if nothing must stop it. And in Manet's *Luncheon in the Studio* the face of the seated figure is intersected by the frame. But no one matched the inspired virtuosity of Degas in suggesting, by the obvious arbitrariness of the boundary or of the arrangement of elements, by the multiplicity of divergent centres, by the distance between the axes of perspective, the sense that everything is snatched in flight from a space that flows onwards, pursues its course—a sense which, far from effacing the image, enhances it by the power which enfolds it and bears it away.

The fact is that classical painting supposes a world of objects and scenes already abstracted from their continuum, each of them possessing a distinctive unity, centre and frame-line. It is the representing of already formed representations. Its effort is directed at reproducing illustrations already detached from their text, and not at producing something which would give precisely the sentiment of a reality existing before that abstracting process (which Courbet suggests when he says that painting is the *concrete*). Classical painting follows the preliminary cutting-out of famous scenes, of wonderful objects, indeed worthy of being, each in its turn, the centre of space and time. The fact that the composition is essential (for Ingres a *dominant* must always be assured by the encounter of form and light) signifies that the aim of the picture is to reproduce an object in its identity and its limits: the composition furnishes the same guarantee as the title. A picture without a centre and with no reason for ending here rather than there would be a picture without an

object, without a subject, embracing only empty space. At the same time, the classical image communicates with the world from which it has been detached: it receives something resembling a beam from a searchlight which brings it into relief, but we feel in the surrounding shadows a whole universe, complete, ranked in a hierarchy, which it illustrates and exemplifies. The modern picture, on the contrary, having no limit, does not refer the viewer back to the total system of images. It sets up for being the world all on its own. That is why it is at once open and self-enclosed, functioning like a timeless moment.

Framed as regards its image, the classical painting requires to be framed in the material sense—and the richness of the frame even possesses its own importance: only with the advent of modern painting does it become thinkable to present canvases without a frame, or even to set them into a wall. And thus it is possible to view old paintings, with no sense of unease, edge to edge in their gilded frames, as we may do today still in Florence in the Palazzo Pitti and in the places luckily preserved from museum studies that have scarcely any meaning for such pictures, since they are in themselves sufficiently distinct, and because, each being an individual plate in a text calling for an infinite number of illustrations, their coexistence compensates their individual character.

For the modern work, on the other hand, the magic wand of symbolism suffices; and it denotes not the particular abstraction of this or that image but the entirely mental frontier which divides painted space from real space; it is outside real space that the painted work can manifest the whole, continuous energy which real space has parcelled out. But the potential for generality which enables it to dispense with a frame demands that the modern work be regarded for itself: like oriental scrolls, each must be viewed separately. Distinct images complement each other; the world of objects needs all its objects, whereas the flashes sent out as the manifestation of one and the same energy, of one and the same origin, can only dazzle each other. No single canvas gives an adequate idea of the work of a great classical painter; to penetrate the work of certain modern painters one example is enough—which does not necessarily signify a lack of invention but rather that on each occasion the game has been *all or nothing*. It is an irony of history, one of the subtlest of cultural comedies, that the fad for great pictorial confrontations should have arisen at the moment when a representative work, in order to produce its full echo, must rise from a ground of solitude.

The New Distance

At the same time that perspective, framing and centring lost their reason for being, it was noticed that the distance at which the painting had to be seen was no longer the same as before.

The criticisms aimed at Manet are all dominated by the charge of incompleteness. Instead of the clearly drawn line there is only a sketchy stroke. Instead of colours blended to obtain the tone corresponding to the object there are only touches of paint, juxtaposed hatchings. Distortions, inversions, transpositions, whatever does not correspond to real outlines is deplored. The critic Paul Mantz wrote of Manet's work in the *Gazette des Beaux-Arts* in 1863: "All form gets lost in his large

Edouard Manet (1832-1883). The Street Singer (detail), 1862. Courtesy Museum of Fine Arts, Boston. Bequest of Sarah Choate Sears in memory of her husband Joshua Montgomery Sears.

portraits of women, and notably in his *Singer*, where, by a singularity we find profoundly disturbing, the eyebrows renounce their horizontal position to range themselves vertically alongside the nose, like two commas of shadow..."

The grievance was to be nursed for a long time to come. Emile Percheron wrote in *Le Soleil* in 1876: "Monsieur Manet, from want of ability, leaves what he does unfinished; and he must imagine an enormous fund of goodwill in the viewer to fill in mentally what is missing in his painting."

Now Zola, in his great study of 1867 ("Edouard Manet" in *Revue du XIX^e Siècle*), replied to the rather hazy ensemble of these criticisms that in order to appreciate such works it was necessary to view them several times and from different distances: "Olympia reclining on white sheets forms a large pale patch on the black background; in this black background is the head of the Negress who is bringing a bouquet, and that remarkable cat which has so amused the public. At first sight, therefore, you distinguish only two shades of colour in this picture, two vivid tints, one rising upon the other. Moreover, details have disappeared. Look at the girl's head; the lips are two thin pinkish lines; the eyes are reduced to a few black strokes. Now look at the bouquet, and from up close, if you will: pink patches, blue patches, green patches. Everything is simplified; and if you want to reconstruct reality you must step back a few paces. Then a strange thing happens: each object takes its proper place in its own plane; the head of Olympia stands out against the background in striking relief; the bouquet becomes a marvel of bloom and freshness."

So, one must come closer, then step back. Several observations and observing positions are needed. And, after all, no observation is final, since there is no position of choice. Let us step back. Then, again, let us approach... Then, once more...

The *new distance* at which the new painting needed to be seen had been mentioned before that page of Zola's. In 1855 Baudelaire observed that a painting by Delacroix made its effect at a distance greater than that of traditional perception; a distance, that is, from which neither the subject nor the composition could be seen. "First it must be noted, and the observation is highly important, that even at a distance too great for the subject to be analysed or even understood, a painting by Delacroix will already produce in the soul a rich impression, whether of happiness or melancholy. It is as if this painting, after the fashion of magicians and mesmerizers, can transmit its thought across a distance. This strange phenomenon is due to the power of the colourist, to the perfect accord of his tones, and to the harmony (pre-established in the painter's brain) between the colour and his subject. It seems that this colour, if I may be pardoned these subterfuges of language to express rather subtle ideas, thinks by itself, independently of the objects it clothes."

(Could not Baudelaire have said as much of Titian, of Rembrandt? No doubt. That this phenomenon was "strange" did not mean it was occurring for the first time, but that it was acquiring a new and, indeed, strange meaning.)

In his *Salon of 1859* Baudelaire referred again, in phrases he would repeat in 1864, still apropos of Delacroix, to this new distance necessary for the manifestation of the general unity, the atmosphere of the painting; but also

necessary for the optical mixing of the separate touches of colour: "The larger the painting, the broader must be the brushwork, that goes without saying; but it is good that the separate strokes should not be physically blended: they blend naturally at the desired distance by the law of sympathy which has associated them. In this way the colour acquires more energy and freshness."

In 1846, in pages prophetic rather than descriptive (the essay *On Colour*), Baudelaire had already written, "The tones, however numerous, would, if they were logically juxtaposed, blend naturally according to the law that governs them."

Baudelaire's aesthetics were influenced, as is well known, by Delacroix. A crucial page of Delacroix's *Journal* (November 1857) opposes the brilliancy of "frank and virtual colours" as used by Titian and Rubens to the "earthy," "subdued" colours of David and his school: pigmentary mixtures aspiring to reacquire "a simplicity that does not exist in nature." Delacroix does not exactly speak of the distance required for this virtuality to operate, but he notes that it retains its force even when the painting is placed in shadow, and that alongside it earth-coloured paintings which live only in full light are extinguished.

All this suggests that, when facing a modern picture, we must stand further back than we are accustomed, since we may lose sight of its subject and even of its composition without inconvenience, the essential thing being the coloured whole which comes to life at a distance, which demands distance for the optical fusion of its juxtaposed dabs of colour.

Optical blending not only gives more brilliance to the colours; it radiates a warmth, an energy which suggests the feeling of space— a space that breathes and vibrates all round us. "In seeking truth and accuracy, let us never forget to give it that envelope which has impressed us," Corot wrote in his notebooks in 1856.

Baudelaire insisted on this idea of "air-space." We see colours, he wrote, only through "the thick and transparent varnish of the atmosphere." If we paint colours in themselves we are left only with false tones: they must be painted as they appear in the air-space. But "there is much less air-space between the beholder and the picture than between the beholder and nature." Since there will never be as much air-space between the eye and the painting as between the eye and the perceived object, the energy of the colour must compensate for a proximity that threatens to dessicate it, to fix it like a dried plant in a herbarium.

The mistake of the painting done in "subdued" colours which we can look at from up close without observing any changes in its appearance, and which does not come to life at a distance, lies in the notion that it captures a space that functions as real space; that we can enter into it, experience its environment. But if we do enter, we enter a discoloured, softened, illusory space, whereas the picture which obliges us to step back acts like an injection of air, provides the equivalent of true depth. Into that short distance, in the small amount of air finding room between the painting and the observer's eye, there flows all the energy of space.

On the next page:
Edouard Manet (1832-1883). Olympia (detail), 1863. Galerie du Jeu de Paume, Louvre, Paris.

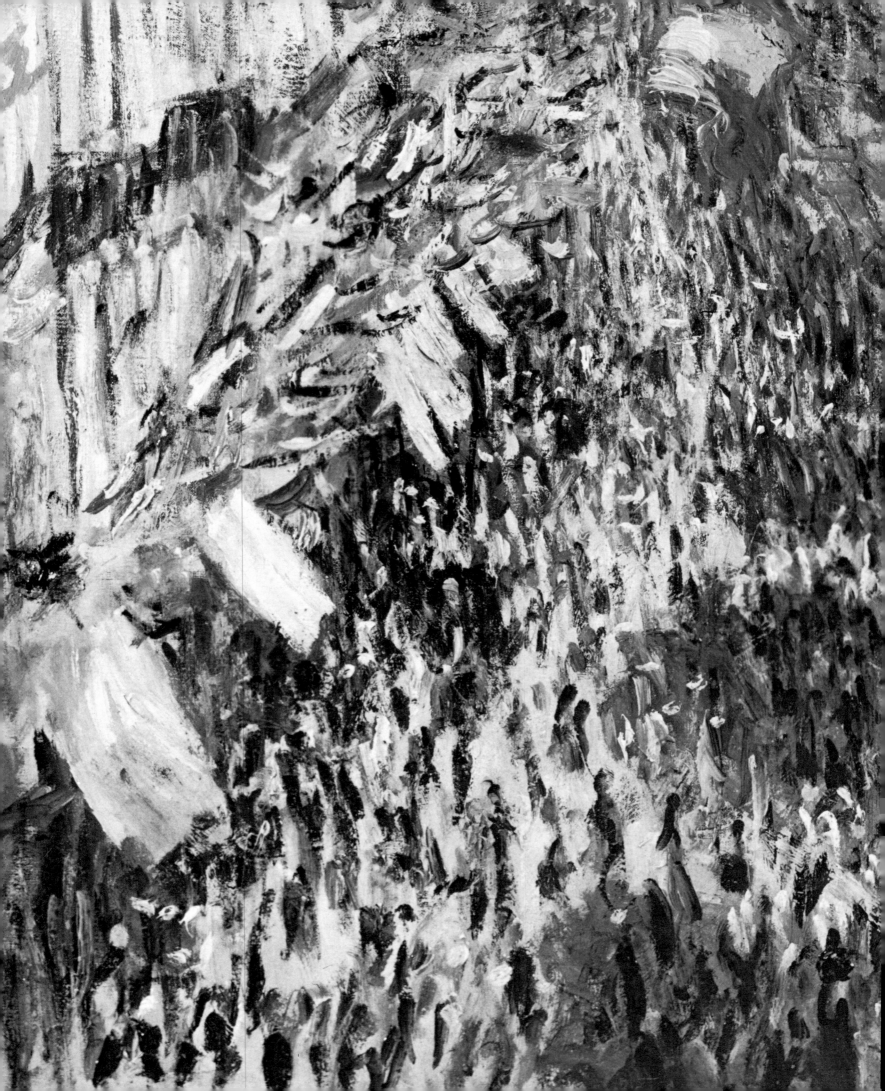

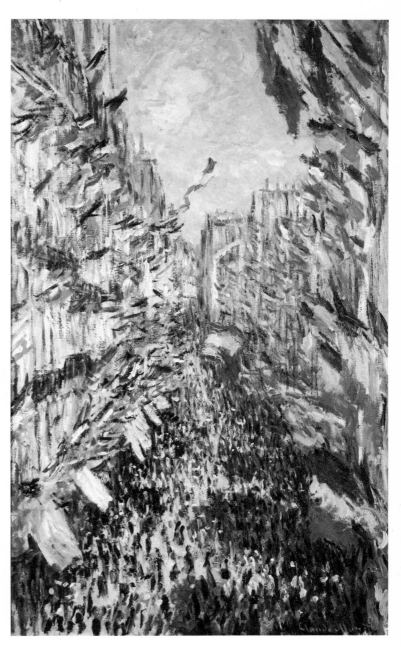

Claude Monet (1840-1926). The Rue Montorgueil with Flags Flying (entire and detail), 1878. (24¼ × 13″) Musée des Beaux-Arts, Rouen.

The new painting must thus be seen at a greater distance than the painting done in traditional perspective. At the same time, it must be seen from a closer distance. At first glance, says Zola...But he thinks that, finally, in order to "read" the painting, to "reconstruct reality," we must also see it from the distance at which the image forms, the distance at which

the hatchings, the lines of the sketch, the liberties taken with the objective outlines, will wisely return to normal: in other words, at second glance.

Some years later (in November 1885), after having read Edmond and Jules de Goncourt's book on the French painters of the eighteenth century, Van Gogh wrote to his brother Theo the following lines about painters who had lived long before him—lines he doubtless could not have written if painting had not taken the path it did from Manet to himself:

"I liked immensely what he says about Chardin. More and more I become convinced that the true painters did not finish their pictures in the sense that has too often been given to *finish*; that is, so crammed with detail that you can look at it with your nose touching the canvas.

"When looked at from very near, the best paintings, and precisely those closest to perfection as regards technique, are seen to have been done with all the colours laid on one alongside the other; they produce their effect only at a certain distance. Rembrandt stuck to that position, in spite of everything he had to suffer because of it (didn't the honest Dutch burghers find Van der Helst far superior because his painting could be admired from up close?)...

"I should like to tell you much more, especially about the food for thought I got from Chardin, in particular concerning colours and not using local colour. I find these words significant: *How can we capture, how can we describe the way this toothless mouth with its infinite refinements is put together? It is all done with just a few streaks of 'yellow' and a few scatterings of 'blue.'*

"When I read that, I thought of Vermeer's view of Delft at The Hague. If you look at it from very near it seems incredible, painted with colours quite different from those you would imagine standing a few steps further back."

So the painter's touch, in relation to the non-finished, is an effect brought out by distance; the "finish" of mediocre painters is that quality which enables the painting to be looked at from up close with no alteration in all that has been seen at a distance. If we come near the "virtual" painting, however, what we find is not a set of tools having no value other than in their use—the wrong side of a painted décor. We see something else; and what we see may be admired *for its own sake*. Now, for Van Gogh this near-sighted look was as valuable as the far-sighted one; when he informs us that these paintings produce their full effect only at a distance he is speaking for the benefit of those who prefer Van der Helst to Rembrandt! And when Zola justifies these close-range observations as a preparation for the final glance that will "reconstruct reality" (and thus the image) he is either going back to traditional perspective or speaking this way only to reassure. Thus, the modern painting, which was intended to be seen from further away, can now be looked at from a closer distance than the classical painting. The reason is that the modern painting is not an image.

But if it is not an image, what can it be?

"Streaks of yellow," said Van Gogh, quoting the Goncourts, "scatterings of blue": *traces*.

Traces, Signs and the Instant

But isn't Van Gogh speaking as a specialist? If he comes near the picture isn't it just in order to see *how it is done*? Can the painter's brushwork present another interest; become an *image* on its own account? The idea at first seems difficult to accept. Its adversaries accuse it of sacrificing the object, of which the painting should give the illusion, to the ostentation of a vain virtuosity. (Ingres objected: "It shows the hand.") But if Delacroix notes the fact that the mark of the brush is no more present in nature than the cut of the engraving or the outline of the drawing, he defends it far less as a term in an autonomous language than as a means of expression. By its brilliancy, by its virtuality, it is fitted to give the sensation of nature.

For Baudelaire the harmony of juxtaposed touches of colour resembles that of nature seen through the magnifying glass of the colourist's eye. He asserts that the work which is *done* may not necessarily be *finished*: what is *done* mani-fests the *doing*, but that is not its purpose; the justification of a non-finished painting is its "realism." Non-finish guarantees the global unity of vision which the finicky retouching of a Horace Vernet or a Paul Delaroche can never attain. But nevertheless, Baudelaire thinks that the sketch is justified only as a preparation for the painting; that notes taken from nature—he was referring specifically to Boudin—are not works of art.

In the same way Corot completed in his studio the pictures which he had sketched out in the open air; he saw only the "makings" of pictures in the early landscape studies made in Italy which we today admire so much (twenty years later only one of them seemed to him worth exhibiting). Constable sought those "dews, breezes, bloom and freshness, not one of

John Constable (1776-1837). Seascape Study with Rain Clouds, c. 1827. (8¾ × 12¼") Royal Academy of Arts, London.

which," he said, "has yet been perfected on the canvas of any painter" (qualities he also designated by the word *warmth*); but he did not restrict himself to his oil sketches, which seem to us today to capture all those qualities even better than his large compositions. The sketch, which is often preferred by the contemporary sensibility to the painting *as a work of art*, was not yet the ideal to which the work of art aspired; it was only the guarantee of its sincerity, its birth certificate, so to speak. At least, before Manet. For the *Déjeuner sur l'Herbe* is perhaps the first large composition in which the style of the sketch seems deliberately selected as the definitive style.

Dabs, hatchings, emphatic or allusive contour lines overstating or understating the objective outline, impastos, everything that "shows" the painter's hand when one observes from up close in order to learn from the execution—is not their purpose merely to make visible what is ultimately seen at a distance? Colours that blend optically are said to possess greater vividness. And yet, can the new painting, its environment and aesthetic, philosophical ramifications, adequately be explained by a realism of showy display? It is simplifying a good deal to oppose the earth colours of David to the virtual colours of Titian, or Van der Helst to Rembrandt. Mixtures of pigments, local colours, flat tints evenly applied can have a vividness equal to that of virtual colours: Zurbarán is not less dazzling than Titian, Piero della Francesca no less than Delacroix; there is nothing more vivid than the icon or the illuminated manuscript. Does not the new painting—which is revolutionary, moreover, not just with regard to colour—aim at something besides this purely retinal joy? Then again, is what we see at a

distance in fact the brilliancy of blended colours? For this to be true the painting would have to spin like a colour-wheel. In reality, what we see is less the brilliancy of fusion—a kind of optical liquid—than a coloured space in which the traces of the hand were recognizable: a language as much tactile as it is visual.

Fromentin, as early as 1850, excused his "impastos" by the necessity to "render the impression": "I know perfectly well that in my *Camp* the paint is too thick…I confess that, not working for posterity at the moment, I take few pains with the material side of painting, provided my impression gets rendered." — What the hand reaches for is not its own manifestation. But the nature of this "real" which the hand wants to make visible is such that it must be rendered along with the traces of the hand. There results something similar in its nature to a hesitation, a trembling; not a blur as of something being diluted or effaced: virtual is the word, as if the painting had not yet fixed upon its forms, as if it were in the act of getting up in the morning. The world before created things, its purificatory freshness, its inceptive energy; the world still forming, not yet formed; the world in its seminal unity, the unity of its texture—its "envelope," Corot said; its "connectedness," said Delacroix.

What remained invisible to an inattentive, distant perception was caught by the "magnifying glass" of the colourist. And this painting may be defined as a retrieval of the visible

◄ Edouard Manet (1832-1883). Garden Path at Rueil, 1882. (32¼ × 26″) Kunstmuseum, Berne, Switzerland.

On the next page:
Edouard Manet (1832-1883). Departure of the Folkstone Boat, 1869. (24¾ × 39¾″) Collection Oskar Reinhart am Römerholz, Winterthur, Switzerland.

94

natural bond of sympathy. The vision of tangency is not to be confused with the taste for meticulous precision or microscopic analysis, or with a "critique of perception": it is rather the resolve to tap the source. The traces do not remain as the mark of a human operation carried out against a submissive nature; they are the frontier where human execution and nature in creation meet, the frontier between the hand and the eye.

When Van Gogh comes near the picture to see how it is done, he does so not as a technician prying into the workings of a visual illusion in order to appropriate it for his own use. In his amazement at the fact that an image may be obtained by means bearing no resemblance to it, that a blue streak should be a mouth, he is wondering not at a human artifice but at a secret affinity. For nature too does not resemble the effects she produces: the mouth does not resemble the mouth. The painter possesses the power to act in the way nature does, bringing forth images that are not contained in their elements. The aesthetic of the non-finished bears witness to the pre-established harmony of art and the real when considered as acts. And the work of art exists neither as an image reconstructed at a distance nor as an element seen up close: it exists in its transit, in the shuttling movement of the eye of the beholder. It is not the representation but the emission of an image. That is why we never enter it. We drop back before the warmth it

world, down to its hitherto imperceptible roots. The world of roots was to receive many names: the virginal, the naive, the profound, the One. It assumed different aspects, moreover, depending on the painter: what Corot or Gauguin discovered was not the same thing as what Manet or Degas caught. But the name of all names, the root of roots, seems indeed to be the act itself that sets up all the variously designated appearances. The world is experienced, sighted, in the process of formation; between it and the painting, which is also taking shape, there is a

▲ Edouard Manet (1832-1883). Portrait of George Moore, 1879. Pastel. (21¾ × 13⅞") The Metropolitan Museum of Art, New York. The H. O. Havemeyer Collection, Bequest of Mrs H. O. Havemeyer, 1929.

Edouard Manet (1832-1883). Madame Manet in the Garden at ▶ Bellevue (detail), 1880. Private Collection, New York.

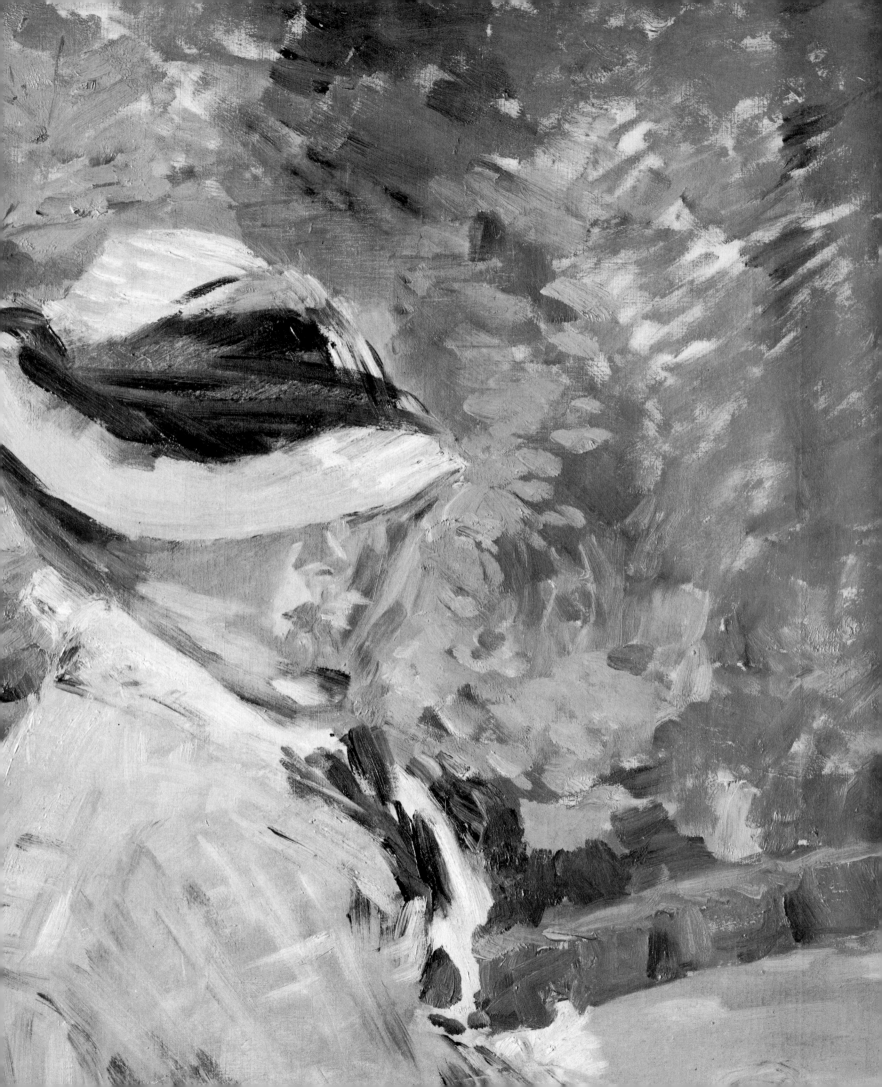

sends out; we come near in order to expose ourselves to its energy-source.

To speak and think in Kantian terms, we might say: *How is it possible that the treatment by the hand is applicable a priori to the world perceived by the eye?* And the answer must be: *because the world itself is a "treatment."*

The retrieval of the visible does not reduce it to the status of a strip of film (implying that it is nothing else) having as its aim that illusion-less demystification sometimes seen in the naturalist novel and flaunted by the contemporary novel of observation. The world is not only what can be measured and observed. It is a manifestation, the mode in which a hidden power is bodied forth. Along with the appearances themselves, their unity, their continuity, their common energy stand revealed. It is their source which is unmasked: that source of light by which colourless space becomes colour, becomes an "illuminating medium," the medium in turn becoming a local habitation and a bond; that energy of matter by which, beneath our eyes, slow changes and the work of time are carried on. The eye sees beyond its power of sight. No doubt it no longer listens; but it touches; it burrows and breathes.

Beyond the world as representation it is the world as existence at which this painting aims. And herein lies the real difference from the past. For although the critique of traditional perspective and especially the opposition to academic painting make the new painting seem a reaction against illusionism, it would be silly to apply the term illusionism to great classical painting. Degas is right, in whatever sense we understand him, when he says that the air that circulates through the paintings of the old masters is not "the air we breathe." The varnish that covers them places a distance between them and the imaginary: it is a pane of frost beneath which objects, even untouched, and however conformable to perspective illusion, are more inaccessible than the leaves of bygone seasons lying on the bottom of the lake. It is only in academic "bourgeois" painting that, with the radiance of the imaginary no longer perceptible, only a visual illusion is left, the success of which justifies the price of the picture.

But both classical and modern painting are *acts of painting.* And both aim at a reality which they neither receive nor give as reality, but rather as *truth.* Both are the movements of a desire, a thought. But classical painting concerns itself with a world of representations, of models which haunt the real, from which they must be extracted and in comparison with which the real is but a rough or watered down copy. For modern painting the question is that of seizing a causal relationship, an action, a piece of work. One kind of painting renders in an image, in a painting, the perfection of an imperfect, badly copied world. The other renders in an image, in a painting, what is unfinished or rather inchoative in a world it would be false to consider complete. From this there follows a very different kind of participation in the painting by the spectator. In one case the participation is contemplative: halted on the threshold of a space into which we cannot really penetrate, we receive, submissively, the triumphant representations; in the other case we enter into a working partnership: the incomplete being who observes and the incomplete thing being formed are commingled at the same stage, in the same instant. And when Baudelaire writes, "What is pure art, according

to the modern conception? It is the creation of a suggestive magic containing the object and the subject at the same time, the world outside the artist and the artist himself," he no doubt places in the artist's camp the soul, the imagination, the emotive vibration, man opposed to nature; but we are justified in understanding him equally to mean that osmosis, that close and so intense relation—the new frontier of the painting that, effectively, asserted itself around 1863.

1863: No doubt the works that deserve our attention from about this time on do not always provide proof of their birth date in the same way. Sometimes the representation of space shows, by its power of synthesis, its detail and its equilibrium, that it goes far beyond a single act of vision. Such is the density in transparency of certain landscapes by Corot: their light but immovable perfection. And if I look at Théodore Rousseau's admirable drawing on canvas, *The Sources of the Lizon*, dated, as it happens, 1863, I can recognize in it none of the signs of modernity which I perceive, for example, in those watercolours done in the same year by Jongkind. By its meticulousness, its slowness—as if, far from seizing an aspect, a profile, the artist had waited for each thing to move into place—by that tightly woven trellis which cross-hatches all the space of the picture, by the precision with which everything is said and not suggested (this form is not a sign but well and truly the drawing of a cloud, and that one is not only a tree but, unmistakably, a poplar...), he comes closer to an etching by Hercules Seghers than to a watercolour by Jongkind.

The fact is that drawing often cuts across the boundary lines of epochs. It is the sanctuary

Théodore Rousseau (1812-1867). The Sources of the River Lizon, 1863. Drawing on canvas. (35 × 46") Louvre, Paris.

of a certain timelessness. There are drawings by Claude Lorraine which seem detached from European tradition and link up with the art of the Far East. And the drawings of Poussin do not belong to the seventeenth century in the way his paintings do. The latter show how he thinks; the former, how he sees. Less dominated by historical styles, drawing owes its nature and diversity to substructures that are personal ways of seeing. But if the style of modern painting is that of personal modes of vision, classical drawing may then appear to anticipate modernity—modernity being, after all, the extension to colour, to the whole canvas, of the natural freedom of the drawing.

It is this side to modernity which enables us to detect it in this drawing by Théodore Rousseau, who is transmitting here the genuineness of a personal vision and, if he does not resort to the virtualities of the non-finished, does not *finish* his picture either, in the way that Meissonier (or a Pre-Raphaelite) would have done. The leafage is seen in masses, not leaf by leaf, as on a page in a herbal. And if that close-

meshed net flung over the sky and the rocks, the trees and their reflections, holds them firmly in place, it also tends to reach beyond the picture frame: it is the tissue of the world itself, from which the landscape is not detached (owing to its achievement, its individual success) but bound by this common texture. The meshwork or slanting scratch-marks of this net capture things, but they are also the marks of a hand giving evidence about itself in relation to things—evidence of their common ground.

By the nature of the brushwork, light or heavy in construction, by its direction and spacing, according to whether it is densely packed like a rainshower or a bundle of long grasses, or whether it goes in whorls or else lies calmly horizontal, and by the thickness of the impasto, the connoisseur of paintings, like a

graphologist, identifies the painter's calligraphy. The connoisseur knows whether he is standing before a Daumier or a Monticelli, or, soon afterwards, a Cézanne. But these identifying marks of a painter's hand are characters, letters of an alphabet that had to be invented in order that the text of the world might be instantly read. They are signs which signify, but which signify something other than themselves, and at times so directly that they cease being signs, as in those drawings by Victor Hugo where the spontaneity of a substance thrust into self-revelation by the accidents of a crease in the paper, an inkspot, a medley of heterogeneous elements, reduces the artist, whom we no longer dare call by that name, to the position of a medium.

We see in Manet, in Jongkind especially, abbreviations, types of ideograms which are not present in nature: for example, the eyebrows capsized into commas of *The Street Singer* and, in Jongkind's watercolours, those long folds, spots, picture-poems which—supposing them removed from their context—no one could read as a cloud, a snail, or the reflection of a boat. Yet they place us in the presence of the cloud, the snail, or the reflection with all the more force in that they burst into bits, in our reading of their script, like the signs of which this script has been itself the reading: like a reading of the world. And the elision of the sign, which is opposed to the firm, finished outline of the object, and is a distorting invention, expresses no desire to invent, distort, or even simplify, but rather the swiftness of a

movement, a swiftness necessary to seize what is the very home ground of this painting, its new continent: the ephemeral—not the stable and complete image round which one may move at leisure, but a view entirely contained in a single act of seeing. The result is that what the sign captures is not an object of another nature, independent of the action exerted on it, but rather an action, an act of perception made visible: the gesture representing a gesture.

It is by this energy common to the sign and what it signifies that this alphabet, so new, nimble and inventive, is defined. For of course this is the painting of the fleeting moment. It is attention paid to what will never return, is already passing; it is a painting of time. Is it too much to say that it grasps existence against a background of death, that it hurries so only because it knows things to be doomed to destruction, that its clutching shows as proof of their precariousness? Among the painters of "modern life" the hats and dresses of a season sometimes take on the melancholy of already yellowed photographs, the fine scent of death of the newspaper just off the press: and that face of *The Balcony* in its porcelain-like fragility, with holes of shadow for eyes and spider-webs of tiny cracks over it, is the face of a youthful corpse.

Yet this background of death exists for us above all in proportion as we place ourselves at a distance from it. Photography, political caricature, the fashion plate, the newspaper editorial, all naively believe in their immediate future; it is the romantic historian who weeps for what is "irrevocable" in them. In itself this painting rejects precisely everything having to do with nostalgia; it reflects only what is immediate: the immediacy of an anger which

rends the veil (as in Daumier), but more often the immediacy of a perception eager to seize and enjoy. In the energy of seizing, the funereal precariousness of time is dissipated. Unquestionably, space has been transformed into time: the skies of Corot, the beaches of Boudin, the cathedrals of Monet all change from one minute to the next like the dancers of Degas; and everything that is painted is branded with the mark of perishable existence. But time, on its

2

1

1. Auguste Renoir (1841-1919). Portrait of Richard Wagner, c. 1900. Lithograph. (17⅛ × 12½") Cabinet des Estampes, Bibliothèque Nationale, Paris.

2. Edgar Degas (1834-1917). After the Bath, 1888-1892. Pastel. (15 × 20⅞") Neue Pinakothek, Munich.

3. Henri de Toulouse-Lautrec (1864-1901). Dance of La Goulue, 1895. (112 × 121") Galerie du Jeu de Paume, Louvre, Paris.

side, has also been transformed into space: the passing finery of a day, the horses and carriages, the café terraces, the house-fronts of the new boulevards, the expressive movements of a face, the attitudes of a body, all these are forms and colours. (The Goncourts aptly observed, in 1862, apropos of a peasant woman painted by Millet, that "the colours seem but the stains from two elements between which this body lives: above, blue like the sky; below, brown like the earth.") Thus death has evaporated; faces tremble not in their mortal precariousness but in the flash, in the brilliancy of their

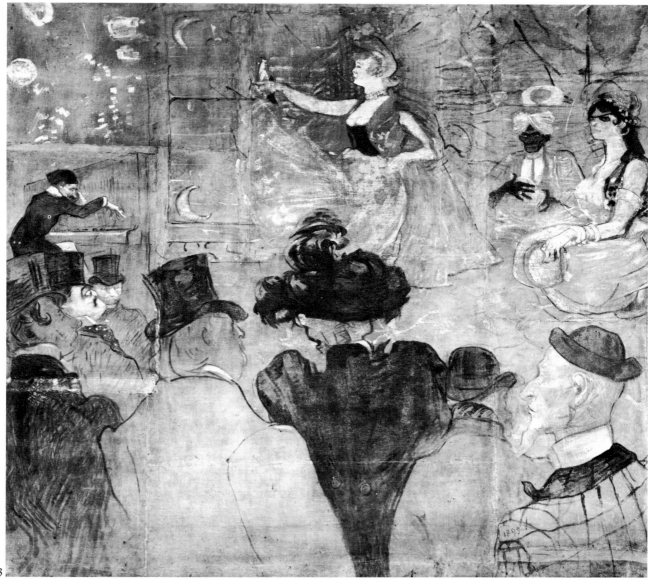

apparition. There is neither nostalgia nor premonition, but the lucidity, the driving force of attention. And what appears is not so much what is going to die as what sparkles in innocent, animal presence, unaware that it has been promised to fate.

No doubt this is not that serenity we later find in the landscapes of Cézanne, where existentialist connotations seem, if not excluded, at least muted, kept out of the way. Here the image is swept along on the wave of a violent sentiment of life. That sentiment is somewhat feverish, but the fever is one of amazement. To cling thus to appearances, to refuse the object, which is the end and sum of successive acts of seeing, is to place more value on the instant than on anything else—and for the reason that it has just been discovered. This *quality of presence*, of which Baudelaire spoke, this quality possessed by each thing, whatever it may be, by the mere fact that it is there, is before anything else the fire of its intensity.

1863 Today

This point in time, 1863, which a critic of the period (Paul Mantz) described as "happy" ("1863 will go down as a happy date: *Libertas artibus restituta*"—freedom restored to the arts), is, surely, a decisive moment; but to do it full justice, to apprehend all its novelty and the force of its rupture with tradition, we must see it as those who lived then could not see it: in the light of the history it inaugurated. It was the brilliant commencement of something which, after maturing for a number of years, would shape itself into a "system" and thereby determine the course of art history.

In the course of this essay we have had occasion to wonder whether 1863 introduced something really new. After all, is it not easy to reconstruct the chain of events? Fantin-Latour painted a "homage to Manet" (*The Studio in the Batignolles Quarter*) after having painted a *Homage to Delacroix*; does not everything begin with Delacroix, who in turn derives from the Spaniards, the Venetians, the Flemish? Yet Delacroix did not like Manet, and he had his grounds. For everything we have emphasized here, we shall always find more than one precedent. What is new is not this or that sign but the sum and convergence of those signs; the formation of a system which affirms and excludes. A system which is, of course, *unconscious* of being one. Let us not set up, in opposition to the idea of a lawless spontaneity, that of a deliberate plan: the logic of the work in progress here can show itself only at the conclusion of that work; and precisely because the "system" is action, not thought, it does not completely cover its allotted ground but rather orients it. The "modernity" I have tried to define is mingled with survivals and deviations.

But if the rupture caused by the bombshell which burst in 1863 is confirmed by its sequel, are we still involved in that sequel? Am I right to entitle this book *The Birth of Modern Painting*? Cézanne took his cue from Manet: it was with good reason that, about 1873, he dedicated to Manet A *Modern Olympia*. But do we still take our cue from Cézanne?

If Manet's modernity, according to Malraux's thesis, is to be found in the substitution of a personal style for the truth of the model, it is easy to conceive as continuous an art which, starting with Manet, would ultimately lead to the heroes of abstract painting (who are summed up in their signatures)—even while we grant that the character which initially defined this art has become more and more accentuated. But if it is true that the painting of Manet and the Impressionists is by no means indifferent towards the real; if, on the contrary, it possesses the sentiment and the aim of moving towards it, of making the picture function at the point nearest the thing it represents, then to speak of accentuation is no longer sufficient: it becomes a matter of a gulf, a derailment. Abstraction, which was not the discovery of 1863, was scarcely to be seen then on the horizon!

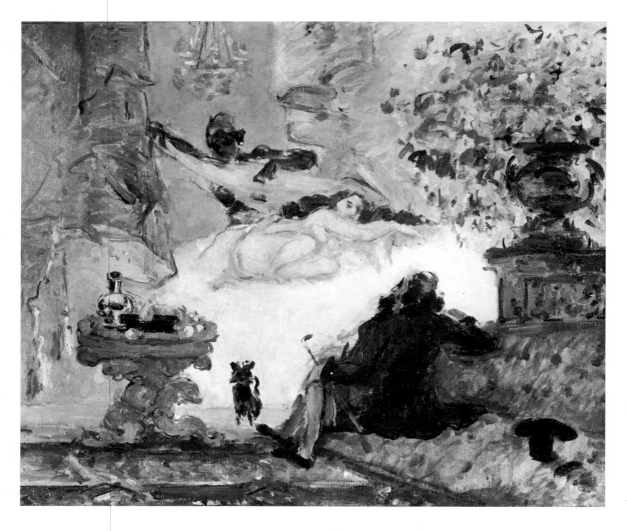

But is abstract art abstract? The debate continues. According to Sir Herbert Read, what distinguishes modern art from earlier periods is the intention, in Klee's famous phrase, "not to reflect the visible, but to *make visible*"—which makes abstraction a part of the entire phenomenon. But is it a matter of making visible what is not visible yet, but awaits the acuteness of our observation at the roots of the visible; or, something of quite another order, is it a matter of transforming an invisible into the visible, through the mediation of the painting? The issue remains ambiguous.

Edouard Manet (1832-1883). Olympia, 1865. Woodcut. (4⅛ × 6¼") Cabinet des Estampes, Bibliothèque Nationale, Paris.

Paul Cézanne (1839-1906). A Modern Olympia, 1872-1873. (18 × 21¾") Galerie du Jeu de Paume, Louvre, Paris.

Robert Morris (1931). Site 1963. Morris reveals Carolee Schneeman posing in the nude as Olympia. New York Theater Rally, 1965.

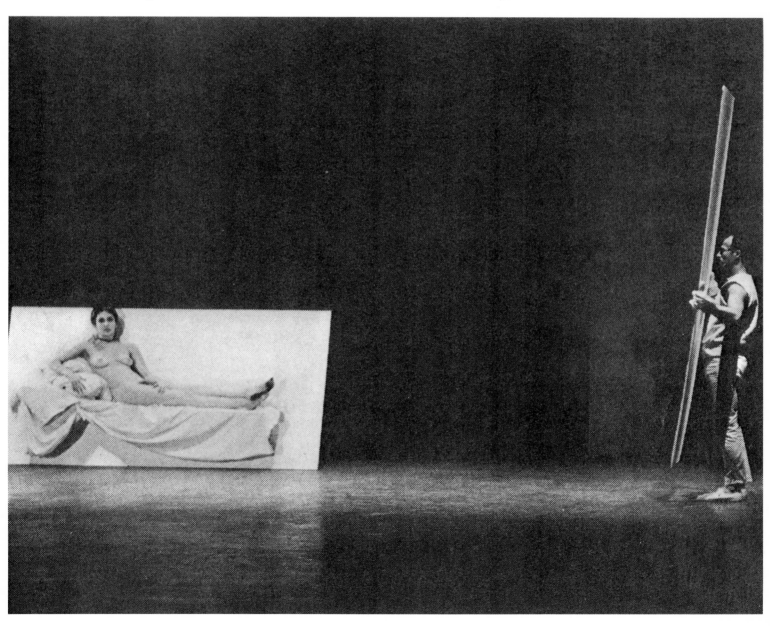

Hans Arp, along with many others, says that abstract art should be called concrete. But by concrete he seems to understand something entirely different from a reference to the real, and this does not get us any further with our problem, which is precisely the relation of modern art to the real. Yet such a reference seems present in the work of a Kandinsky or a Mondrian, since one of them, as he paints, remembers the blackness of a Florentine night; the other, the branches of a tree, the waves of an ocean, and, at the last, the windows of Broadway. One of them yearns for a nature that is freer, more teeming; the other, for a nature that is simpler and better ordered. Both, starting from nature, offer her the tribute of their paintings.

The notion of an art without reference is difficult to conceive; is not the painting of repetition, of accumulation—notably in the United States—figurative when considered in relation to architectural reality, to the urban environment? And at this very moment a whole art is being elaborated—the offspring of the "ready-made art" of Marcel Duchamp—which functions like *trompe-l'œil*, mingles with the products of technology, and like an insect with mimetic powers, takes on the appearances of the object while throwing off those of art, because it wishes either to make the artistic scheme of things impossible or to explode the vanity of the object: perhaps both. In any case it is a long way from this unavoidable reference to the real, having nothing to do with the essence of the work taking shape—and a still longer way from this aggressive and, to say the least, critical mimicry—to that concern for the visible world which unites Manet, Cézanne and the Cubists.

In the eyes of classicism, painting meant painting of the world, with the result that between the painted image and the model there always remained that distance of which an obviously artificial space makes us aware. Subsequently, for Manet, for the Impressionists, for Cézanne, for the Cubists, the world and painting strive to become the same thing, with the result that between the painting and the other pole of the visual relation what matters is no longer the distance or the accord between a representation and its object, but a kind of fusion, a blaze which is momentary and yet never exhausts its fuel, finding always and everywhere new combustibles, new challenges. Finally, from the first abstract watercolour by Kandinsky onwards, art has become the world without a relation of duality, of reciprocity, the picture proceeding from the picture, the product coming from the product; and, conversely, the world (whether artificially produced or in its natural state) can become art without concessions, without modification, without duality.

If it is possible to speak in these terms, it is difficult indeed to claim that the 1860s and the 1970s are travelling on the same road! And yet if, at a given moment, the world had not been seized at the point nearest the artistic *doing*, the art based entirely on the *doing* would not have come about. The event that occurred in 1863 paved the way to the most recent avatars. It is understandable that an art which, coming ever closer to the thing it represents, captures it in a form we have not seen before, should appear to us as something *produced*, not *reproduced*, and should commit us, in turn, to produce so as to exclude what originally still derived from an art of reproduction. It is understandable that, to

those on the receiving end, this art should appear as the invention of a new script, personal or collective: the language of a language.

In the final evolution of our art (and I am thinking here of literature as much as of painting) it may be that this interpretation (impoverishing because it drains the work of its intention, uproots it from its origin to transplant it to the groves of culture, amidst the forms of the museum and, later on, amidst those other products which are the forms of industrial civilization)—this critical reading will perhaps have played its part. But the creative impulse was something different; its intention was objective, and if it did accidentally go off the rails that was because the direct contact between the eye and the visible touched off a kind of blinding flash in which the object as pretext disappeared, in which the act of perception consumed the perceived, leaving only the unquenchable fire of the perceivable. Thus realist objectivity bears within it the germs of its own overthrow: what it discovers are not real objects but what were called, almost the moment they appeared, transpositions and symbols, and later would be more accurately called: traces, signs, brilliancy of painting.

I have used the word civilization; and 1863, as it happens, gave its first artistic expression to a civilization which is still our own. There is where we may find an irrefutable continuity. The Salon des Refusés opened a door which has not closed since. It consecrated a social situation of art which we know to be defined by an entirely new separateness, by an unprecedented schism. Previously, in each epoch, there had been a style including its own hierarchy of masters and disciples, those with higher and lower gifts. After 1863 there were two styles. Taken at their extremes, one of them no longer made sense because it referred to the context of a defunct civilization, whereas the other gave to the new civilization its artistic direction. The artists were divided less on the ground of their initial gifts (a "reactionary" painter might be more gifted than some other) than by approval or censure arising from the direction they chose to pursue. Those who are out of step with history cannot confer a complete existence on their works, which remain weakened, anaemic, or, when talent or even genius is present, bizarre, dream-like, alienated.

Can we say that this schism, revealed in 1863, has ceased to exist? Certainly not. The Rejected, and their successors, have won the war without reaching unanimity for all that. A small minority has imposed its dominant or even exclusive presence in museums and private collections; it has ensured high prices for itself on the market. But it has not disarmed a resistance which requires some explanation.

To speak of an academic routine is inadequate. On the walls of the Metropolitan Museum I was surprised to see Rosa Bonheur and Carolus-Duran alongside Manet and Degas, and in the Louvre, Gérome next to Ingres. Does this show a desire to enlarge the market? An accord between narrative painting and scholarly commentary? The misunderstood influence of today's hyperrealists? To grasp the deepest cause we must perhaps compare these recent and limited reactions of the West to the immovable position of the Soviet Union. In the East painting remains traditional: only the subjects have changed. And the Soviet bureaucratic system is not alone in this: every

"people's" regime is liable to that same tendency. We must also ask why we ourselves, who like and understand new art, remain attached as well to the art of the past: there are good reasons for the importance which the museum has acquired. Of course, the great tradition for which we may feel nostalgia, whether it be imposed by a particular political regime or encouraged by this or that backward-looking institution, is quite incapable of winning back a unanimous public, for the simple reason that it is quite incapable of life. In Leningrad, in Moscow, in the cautiously half-opened store-rooms of museums, I recall having seen canvases that in Paris I should have thought as good as extinguished, sparkle with all their primitive fires! How quickly the artistically spurious would restore our taste for *peintres maudits*, for audacities of which we may have grown weary! With what fervour would we long for a new Salon des Refusés!

No matter; come what may, the schism will remain, both within and outside ourselves. One thing that will never be seen again is the throng assembled in the central panel of Van Eyck's *Ghent Altarpiece*. New art is "alive" because it speaks to us of a living civilization, but we do not really accept that civilization. That is why the art of the past speaks to us with so much force; that is why the art which is an extension of it, however weakened, always obtains our complicity. The schism is still with us because man himself is not a united being; his lucidity is at odds with his desire. 1863 remains up-to-date to the extent that the civilization it expresses (magnifies and de-nounces) remains our own: the first civilization without a common spiritual ground. The paint-ing of yesterday belonged to the very people who were ignorant of how to look at it, because it had a meaning related to a common faith. Since Manet, painting belongs only to those capable of grasping the meaning it possesses for itself; not that this meaning refers to painting alone, but to *a world seen as painting*. To see the world in this light cannot be "the most com-monly shared thing in the world." And the ingenious, wonderful, or absurd gadgets which supplant the "immediate freshness of the encoun-ter," the tricks of *trompe-l'œil*, the *ready-mades* which put on the appearance of things only to show that art no longer has its place among them, can succeed no better in belonging to everyone. To fabricate products and objects in parody or accusation, to contest the work of art, is a calling even more specialized than to try to make it live on a perception exclusive to itself: revolutionary art is nothing but an art for artists.

After having belonged to civilizations which possessed the common ground and bond of a vision of man and his relation to existence, art, however clamorous its cultural reputation, however high its market price, has been sent into exile on the outskirts of a society for which it can be only a tolerated luxury or a harmless aggression; the degree of leisure or of revolt permitted by the inadequacy of a civilization. And this fringe, discontented with its lot, does not even oppose a centre that is sure of being one! Art is marginal only in relation to an aggregate without unity and without value. Art is marginal only because there is no centre! There is no longer a unanimous art because there is no longer any common value. If we feel more and more uneasy, frustrated by what we have, cut off by what we share, the separated value of art can only take on exasperated forms

that go on incessantly wearing themselves out. 1863 ushered in this difficult, perhaps doomed art. Let us remember Baudelaire's remark to Manet: "You are foremost in the decay of your art." From the beginning, modern art is marked by some kind of flaw. The great art it replaces, whose "impostures" it so vigorously denounces, was richer. It is a flaw that, once consciously perceived, will ravage modern art. But in 1863 we are far from such lucidity! The new art is seen as instinctive, liberating, vital, inventive, a marvel of youth. And whatever the avatars of its old age, it is this youth that still enchants us.

Alain Jacquet (1939). Déjeuner sur l'Herbe, 1964. (69 × 77″) Galerie M.E. Thelen, Cologne.

List of Illustrations

Illustrated Index of
Works Mentioned

Index of Names and Places

List of Illustrations

Illustrated Index of Works Mentioned

This index does not pretend to be complete, but it lists and illustrates the great majority of the works referred to in the text. Also included, in their entirety, are works of which only a detail is illustrated in the book. The artists are listed in alphabetical order.

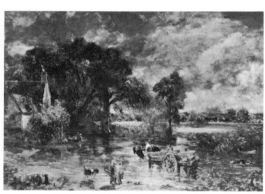

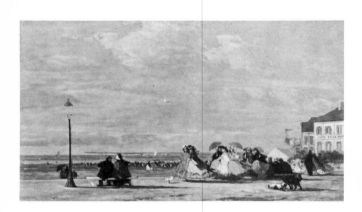
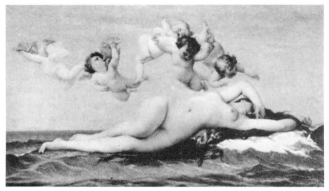

Paul BAUDRY (1828-1886)
The Pearl and the Wave, Salon of 1863

Rosa BONHEUR (1822-1899)
The Horse Fair, 1853

On n'est plus en sécurité! même aux sculptures! M. Courbet
s'est introduit aussi par là.

Eugène BOUDIN (1824-1898)
The Empress Eugénie on the Beach at Trouville,
1863

Alexandre CABANEL (1823-1889)
Birth of Venus, Salon of 1863

Emile-Auguste CAROLUS-DURAN (1837-1917)
Mrs William Astor, 1890

Jean-Baptiste CARPEAUX (1827-1875)
Ugolino and His Children, 1860

CHAM (1819-1879)
"Even with sculpture we're not safe. Monsieur
Courbet has slipped in that way!" Caricature
from "Cham au Salon de 1863. Deuxième
Promenade"

Théodore CHASSÉRIAU (1819-1856)
Allegorical murals at the Cour des Comptes,
Paris, 1844-1848

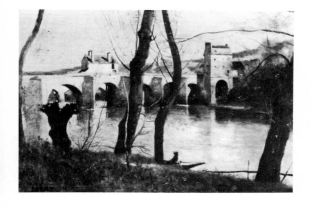

Théodore CHASSÉRIAU (1819-1856)
The Toilette of Esther, 1841
Two Sisters, 1843

John CONSTABLE (1776-1837)
The Hay Wain, 1821

Camille COROT (1796-1875)
Belfry of Douai, 1871
Bridge of Mantes, 1868-1870
Bridge of Narni, 1826

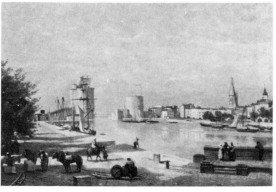

Camille COROT (1796-1875)
Civita Castellana, 1826-1827
Memory of Mortefontaine, 1864
Road to Méry, near La Ferté-sous-Jouarre,
Salon of 1863
Rosny-sur-Seine, 1844
View of La Rochelle, 1851

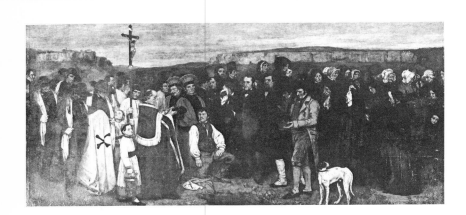

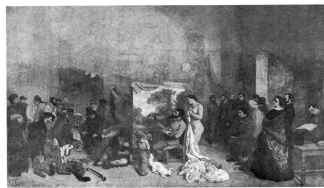

Gustave COURBET (1819-1877)
A Burial at Ornans, 1850
Covert of Roe-Deer, 1866
Girls on the Banks of the Seine, 1856
The Irish Girl, 1866

Gustave COURBET (1819-1877)
The Meeting (Bonjour Monsieur Courbet), 1854
The Painter's Studio, 1855
Portrait of Baudelaire, 1848
Portrait of Laure Borreau, 1863
Proudhon and His Children, 1865

Gustave COURBET (1819-1877)
Return From the Conference, 1862-1863
Saintes, 1865
The Shaded Stream, 1865
Stone-Breakers, 1849

Gustave COURBET (1819-1877)
The Trellis, 1863
The Trout, 1871 or 1873
Valley of the Loue, c. 1849
Woman in a Podoscaph, 1865
Young Fisherman in Franche-Comté, Salon of 1863

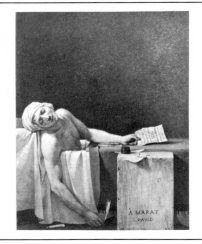
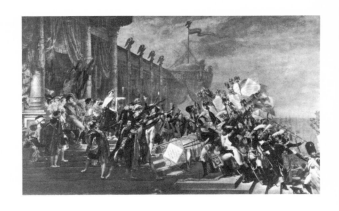

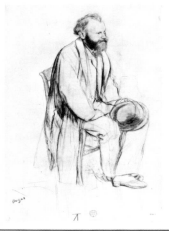
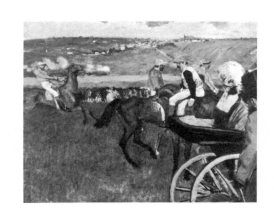
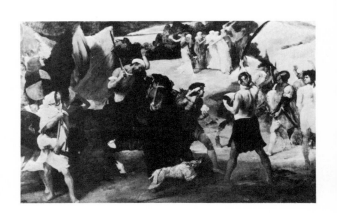

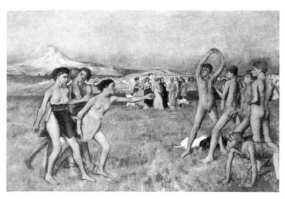

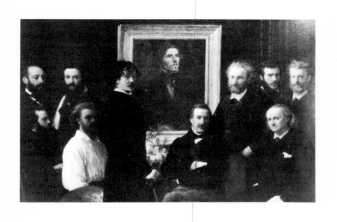

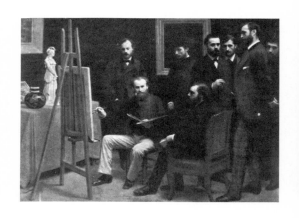

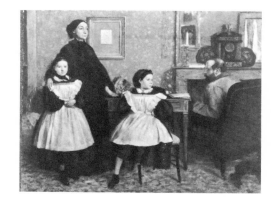

Jacques-Louis DAVID (1748-1825)
Death of Bara, 1794
Death of Marat, 1793
Distribution of Eagles, 1810
Luxembourg Gardens, 1794

Edgar DEGAS (1834-1917)
Bellelli Family, c. 1859-1862

Edgar DEGAS (1834-1917)
Alexander and Bucephalus, c. 1861-1862
Gentlemen's Race, Before the Start, 1877-1880
Jephtha's Daughter, c. 1861-1864
Misfortunes of the City of Orleans, 1865
Monotype Landscape, 1890-1893

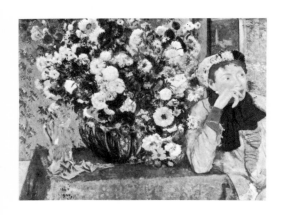

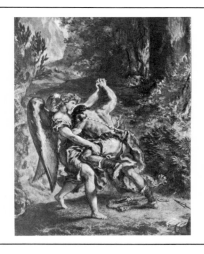

Edgar DEGAS (1834-1917)
Manet Sitting on a Chair, 1865-1870
Semiramis Building a City, 1861
Spartan Girls Challenging the Boys, 1860
Woman with Chrysanthemums, 1865

Eugène DELACROIX (1798-1863)
Jacob Wrestling With the Angel, 1858-1861

Henri FANTIN-LATOUR (1836-1904)
Homage to Delacroix, 1864
Portrait, at the Salon des Refusés, 1863
The Studio in the Batignolles Quarter, 1870

Hippolyte FLANDRIN (1809-1864)
Napoleon III, Salon of 1863

Émile FRIANT (1863-1932)
All Saints' Day, 1888

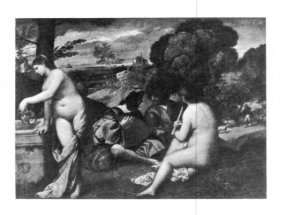

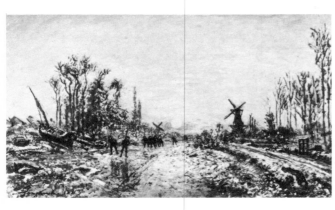

Eugène FROMENTIN (1820-1876)
Arab Camp, c. 1850
Hawking in Algeria, Salon of 1863

Charles GARNIER (1825-1898)
Paris Opera House, 1867-1875

Jean-Léon GÉROME (1824-1904)
Cockfight, 1846

Théodore GÉRICAULT (1791-1824)
The Raft of the Medusa, 1818

GIORGIONE (c. 1477-1510)
Concert Champêtre

Antoine-Jean GROS (1771-1835)
Bonaparte Visiting the Plague-House of Jaffa, 1804

Victor HUGO (1802-1885)
Fantastic Landscape, 1858

Jean-Auguste-Dominique INGRES (1780-1867)
Angelica, 1819
The Golden Age, 1843-1847
Jesus Among the Doctors, 1862

 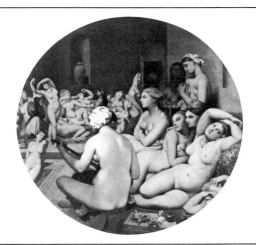

Jean-Auguste-Dominique INGRES (1780-1867)
View of the Belvedere of the Villa Borghese in Rome, 1807
Roman Campagna With the Aqueduct of the Villa Borghese, 1807
The Casino of Raphael in Rome, c. 1806-1810
Monsieur Bertin, 1832
The Turkish Bath, 1862

Johan Barthold JONGKIND (1819-1891)
Skaters on a Canal in Holland, 1863 (probably at the Salon des Refusés, 1863)
Merchant Ships and Fishing Boats at Honfleur, 1865
Ruins in the Nivernais (Château de Rosemont), 1861, at the Salon des Refusés, 1863

Hippolyte JOUVIN
Troops marching over the Place de la Concorde on the Emperor's birthday, August 15, 1862. Photograph

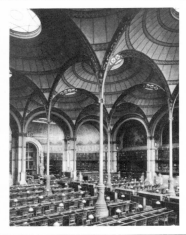

 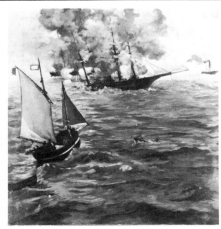

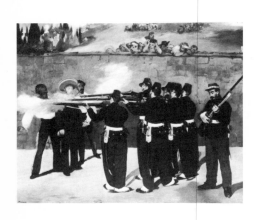 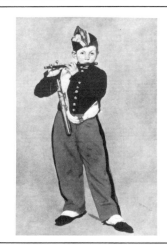 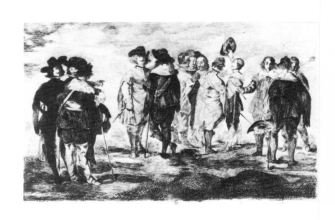

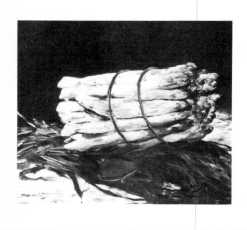 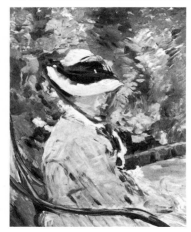 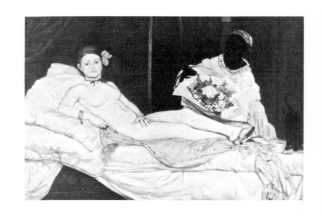

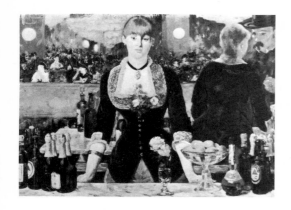
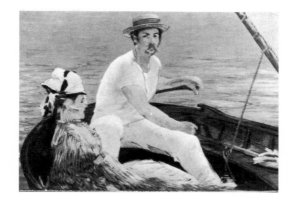

Henri LABROUSTE (1801-1875)
The Reading Room in the Bibliothèque Nationale, Paris, 1855-1868

Hector LEFUEL (1810-1881)
Cour de Manège, Louvre, Paris, 1854-1857

Silvestro LEGA (1826-1895)
Woman Reading to a Girl, 1875

Edouard MANET (1832-1883)
A Masked Ball at the Opera, 1873
A Bar at the Folies-Bergère, 1881
Boating, 1874

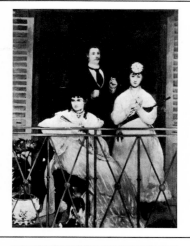
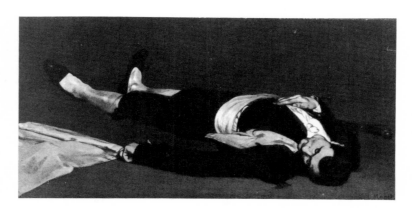

Edouard MANET (1832-1883)
Christ with Angels, 1864
Combat of the Kearsarge and the Alabama, 1864
Concert in the Tuileries, 1862
The Balcony, 1868-1869
The Dead Toreador, 1864

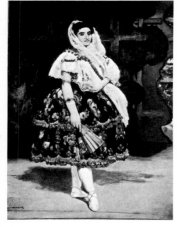
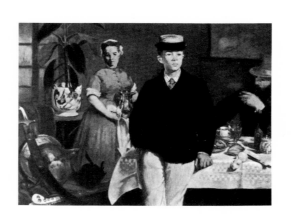

Edouard MANET (1832-1883)
The Execution of Maximilian, 1867
The Fifer, 1866
Little Cavaliers, etching, 1860, at the Salon des Refusés, 1863
Lola de Valence, 1862
Luncheon in the Studio, 1868-1869

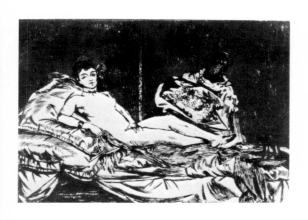
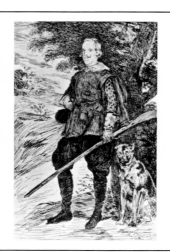

Edouard MANET (1832-1883)
Bunch of Asparagus, c. 1880
Madame Manet in the Garden at Bellevue, 1880
Olympia, 1863
Olympia, etching, 1865 or 1867
Philip IV, after Velázquez, etching, 1862, at the Salon des Refusés, 1863

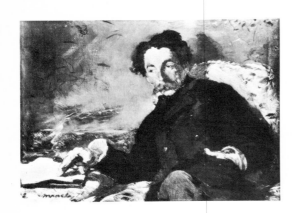

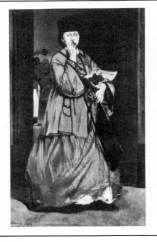

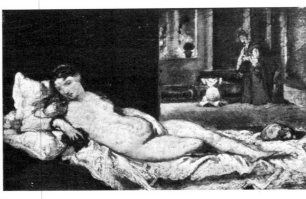

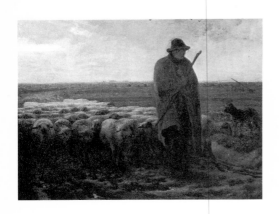

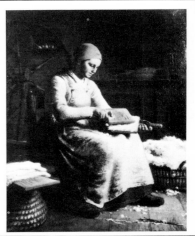

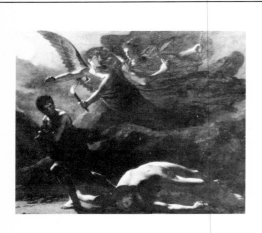

Edouard MANET (1832-1883)
Portrait of Mallarmé, 1876
Portrait of Henri Rochefort, 1881
Rue Mosnier with Flags Flying, 1878
The Races at Longchamp, 1864

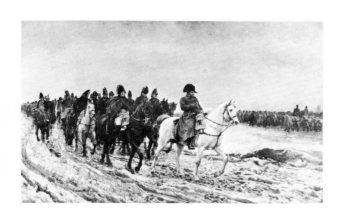

Edouard MANET (1832-1883)
The Street Singer, 1862
Venus of Urbino, 1856

Ernest MEISSONIER (1815-1891)
Battle of Solferino, 1863
Campagne de France 1814, 1864

Jean-François MILLET (1814-1875)
Offering to Pan, 1845

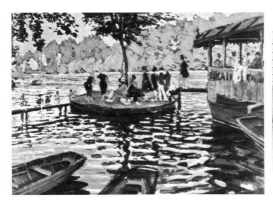

Jean-François MILLET (1814-1875)
A Shepherd Bringing in His Flock, Salon of 1863
Springtime, 1868-1873
Woman Carding Wool, Salon of 1863

Claude MONET (1840-1926)
La Grenouillère, 1869

PARIS
Interior of the Gare du Nord, 1863

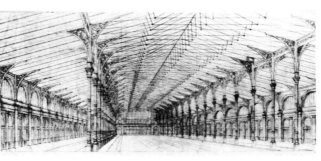

Pierre-Paul PRUD'HON (1758-1823)
Justice and Vengeance Pursuing Crime, 1808
Portrait of the Empress Josephine, 1805

Pierre PUVIS DE CHAVANNES (1824-1898)
Sketch of Salome
Rest, 1867, replica of the painting at the 1863 Salon
Work, 1867, replica of the painting at the 1863 Salon

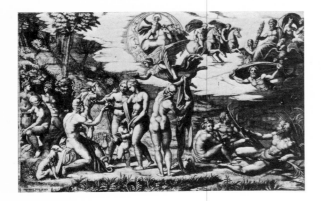

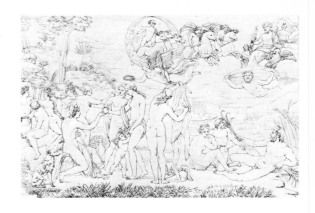

MARCANTONIO RAIMONDI (c. 1480-c. 1534)
Engraving after Raphael's Judgment of Paris

RAPHAEL (1483-1520)
The Judgment of Paris

Pierre-Auguste RENOIR (1841-1919)
Moulin de la Galette, 1876

Auguste RODIN (1840-1917)
Man with a Broken Nose, 1864

J. M. W. TURNER (1775-1851)
St Denis, Moonlight, 1829. Engraved in 1835
by S. Fisher for Turner's Annual Tour - The
Seine.

James WHISTLER (1834-1903)
The White Girl, at the Salon des Refusés, 1863

Franz Xaver WINTERHALTER (1805-1873)
Portrait of the Empress Eugénie, 1855

Adolphe YVON (1817-1893)
Capture of Malakoff Fort at Sevastopol

Index of Names and Places

Published July 1978
Printed by Imprimerie Studer S.A., Geneva
Book design and layout by Arlette Perrenoud

PRINTED IN SWITZERLAND